BEGINNING
ILLUMINATION

BEGINNING
ILLUMINATION

Learning the Ancient Art, Step by Step

CLAIRE TRAVERS

Schiffer Publishing Ltd

4880 Lower Valley Road • Atglen, PA 19310

I dedicate this book to Miguel and my parents,
and Isabelle Esquié for her proofreading.

This book is also dedicated
to all those who are beginning the marvelous art
that is illumination,
with the hope that they'll take as much pleasure
from it as I do!
And especially, to my loyal students.

Library of Congress Control Number: 2015960255

Originally published as *Initiation Enluminure* by Fleurus Éditions, Paris © 2006 Fleurus Éditions. Translated from the French by Omicron Language Solutions, LLC.

Cover design by Molly Shields

ISBN: 978-0-7643-5027-6
Printed in China

Published by Schiffer Publishing, Ltd.
4880 Lower Valley Road
Atglen, PA 19310
Phone: (610) 593-1777; Fax: (610) 593-2002
E-mail: Info@schifferbooks.com
Web: www.schifferbooks.com

For our complete selection of fine books on this and related subjects, please visit our website at www.schifferbooks.com. You may also write for a free catalog.

Schiffer Publishing's titles are available at special discounts for bulk purchases for sales promotions or premiums. Special editions, including personalized covers, corporate imprints, and excerpts, can be created in large quantities for special needs. For more information, contact the publisher.

We are always looking for people to write books on new and related subjects. If you have an idea for a book, please contact us at proposals@schifferbooks.com.

Other Schiffer Books on Related Subjects:
Decorating Eggs: Exquisite Designs with Wax & Dye, Jane Pollak, ISBN 978-0-7643-4654-5
Medieval Cooking in Today's Kitchen, Greg Jenkins, ISBN 978-0-7643-4842-6
100 New York Calligraphers, Cynthia Maris Dantzic, ISBN 978-0-7643-4898-3

CONTENTS

A SHORT HISTORY OF ILLUMINATION

Historians generally attribute the word "illuminated" to the Latin *illuminaire*, meaning "to highlight." It describes both the manuscript itself and the method of creating it. In Europe it was typically practiced in the medieval period, and the patterns and styles varied considerably according to the time period and the location.

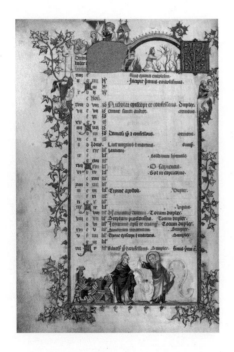

▲ *Jean Pucelle, illustration taken from* Bréviaire de Belleville *(fourteenth century, France).* © *Bibliothèque nationale de France.*

Why Were Manuscripts Illuminated?

The first function of illumination was to clarify the text it accompanied: indeed, medieval scripts had no punctuation, page numbers, chapters, or paragraphs. Therefore, to make reading easier, a certain number of visual marks were put on the pages.

Red and blue initials—first letters that are larger than the other text—were unadorned at first, and played the role of an indent; they were also called "miniatures," because these letters were created using minium, an orange-red lead based pigment. The red initials called rubrics (from the Latin *ruber* meaning red) allowed the reader to rapidly identify the contents on the page. The initials served to classify the text's priorities: the most modest initials were often simply painted red, blue, or green. They became more and more decorative; there were filigreed initials (with small flourishes that continue in the text's margin) or champie initials (usually gold).

They occupied a very important place on the page: we find initials adorned with plants, animals, or interlacing; animated initials, where the body of a person was twisted to form the letter (as on the opposite page); and historiated initials, those containing scenes or images, which were used to highlight a narrative scene and which helped the reader to find his place by calling his attention to the contents of the chapter. The flourishes surrounding them were continued down the margin, giving birth to magnificent friezes of vine or acanthus leaves, frequently found in the Gothic period. The margin left space for freedom of expression: for small non-religious figures hiding between the leaves, for drolleries…

So, illumination became a true decoration that illustrated the text and highlighted its meaning, the images often being more explicit than the words. The gold or silver leaf concretely represented the light, but it also symbolically reflected Divine Light.

The Evolution of Styles

Illumination is an art that thrived in the period from the fall of the Roman Empire in the fifth century to the sixteenth century, when printing replaced the hands of the scribes and the limners. Until the twelfth century, literary production was carried out in religious establishments in the west, mainly in monasteries. The most frequent books to be found were religious texts like the Old and New Testament, the Pontifical, the Psalter, the Antiphonary, the Sacramentary, the Book of Gospels, the Epistles, Lectionaries, the Missal, and the Book of Hours.

The creation of suburban schools in the twelfth century and universities in the thirteenth century meant the development of books for students and the appearance of real libraries, which had the task of distributing manuscripts in accordance to the study program. Intended for silent, individual reading, the books became smaller to, finally, be transportable. Numerous prayer books, small Bibles, breviaries, and books of hours were created for laymen. Even so, a lot of other subjects were covered: medicine, art, theology, grammar, philosophy, botany, astronomy, mathematics, and law, but also songs, chivalric romances (the Arthurian cycle for example), bestiaries, and more.

It isn't easy to precisely define an artistic period, because illumination is an art that is continually mutating and progressing, intimately linked to spiritual, political, social, and economical transformations at

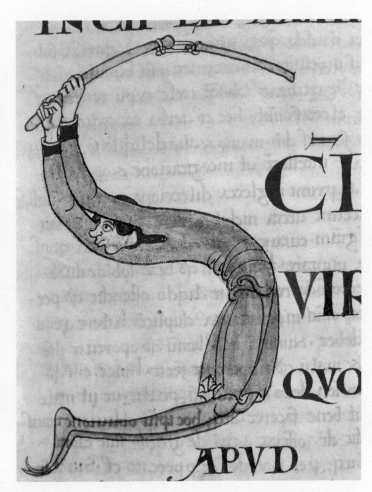

▲ *Initial "S" taken from "Commentary on Job" by St. Gregory the Great (540-604), Citeaux Abbey (twelfth century, France).*
© *Bridgeman Art Library.*

any given time; but here is a basic list of the important periods of the history of illumination in Europe.

The first general period, called "hieratic," was from the fifth to the thirteenth centuries. Religion was the dominating characteristic; the large majority of illuminated manuscripts were created by and for monks (carried out by clergymen and then by secular clergymen attached to Episcopal churches). Following this, the second general period was called "naturalistic."

The High Middle Ages
(Fifth to Eighth Centuries)

This period saw the growth of two distinct styles: the insular style and the Merovingian style. In the newly Christianized England and Ireland, missionaries created manuscripts whose patterns (spirals and interlacing) were largely derived from Celtic metalwork. Decoration was plentiful, taking up an entire page: these are called "carpet pages." Initials dominated the page and were composed of stylized human and animal forms as well as highly complex geometrical shapes. The best-known works are the Lindisfarne Gospels, the Book of Kells, the Codex Aureus with its Byzantine influence, and the Book of Durrow.

The Merovingian style was distinguished by its initials in the form of animals and its bright colors. The circle, drawn with a compass, played an important role. Rustic calligraphy was used, first Old Roman cursive and later uncial. Gold leaf wasn't yet in use, so orpiment pigment, an arsenic trisulphide, was mixed with saffron and bull spleen to give the illusion of gold. The colors were applied as flat tints: there were no gradations. Among some of the great works of the period are the Luxeuil Lectionary and the Corbie Psalter.

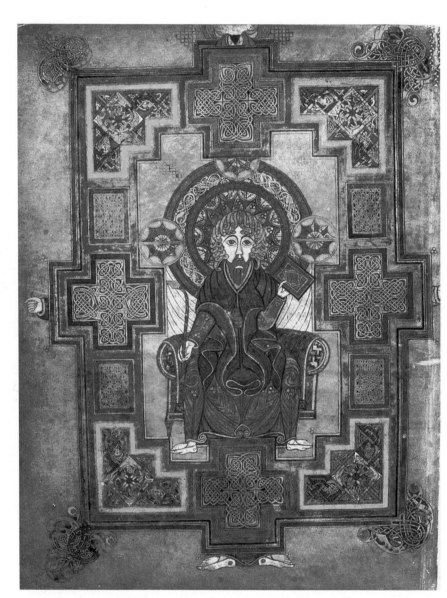

▲ *Portrait of St. John, illuminated manuscript from the* Gospel of St. John *(Ireland, 8th century).*
© *Trinity College, Dublin.*

The Carolingian Period
(Ninth to Tenth Centuries)

This period corresponded to a revival of the elimination of illiteracy and the instruction that followed, through books, of course. Royal commands were numerous and funds for gold were available, because it represented power. Sometimes silver foil was used, which sadly has oxidized over time.

Writing became more legible with the appearance of the Caroline minuscule, the base of our modern script, created by the English scholar Alcuin, Abbot of Tours. The historiated letter—an initial in which figures tell a story—was developed. Of the schools in Tours, Reims (which produced the Utrecht Psalter), Corbie, Saint-Denis, and Metz are the best-known. The colors were less bright than during the Merovingian period, but more varied.

Carolingian illuminated manuscripts ended with the fall of the dynasty of the same name. It gave birth to Ottonian art (German art from 860 to 1130), and then Romanesque art.

The Romanesque Period
(Late Tenth to Late Twelfth Centuries)

Romanesque illuminated manuscripts were inspired by ancient art, Carolingian art, and insular art, with Oriental Byzantine art as a finishing touch. Following invasions from Normandy that destroyed a number of abbeys, monks found refuge in northern France, an influence that then became extensive. English influence was predominant in Fleury, Vendôme, Saint-Omer, Angers, Mont-Saint-Michel, Citeaux, Luxeuil, and Arras. Forms grew less rigid, and nature was seen more realistically. Regular shapes were

fuller and rounder, characters were better balanced, and garments more flexible, although there was no real defined style.

Southern France developed another style of illumination. Its influence came from Spain and Italy; the schools in the south presented fewer variations than those in the north. Toulouse, Albi, and Moissac developed interlacing with a lot of flexibility and lightness.

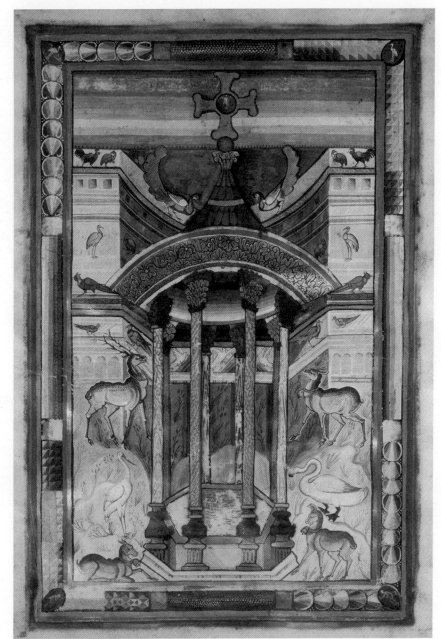

▼ *"La Source Mystique," illuminated manuscript taken from the* Gospels of Saint Médard de Soissons *(beginning of the ninth century).*
© *Bibliothèque nationale de France –Akg-images.*

The Gothic Period
(Thirteenth to Sixteenth Centuries)

The Gothic style of illuminated manuscripts began around 1250, under the reign of Saint Louis, with an evolution around 1285 to 1292 after Philip IV "The Fair" was crowned. The garments changed their appearance: they became fuller and cascading. The characters were looser-limbed, their faces more defined. Master Honoré, Jean Pucelle, and Jean le Noir foresaw the question of perspective. The colors were softer, blending better, and a relief effect began to appear. Illumination was turning toward real painting, resembling those works done on an easel. Drawings became more exuberant, very nearly Baroque. Some artists have never been equaled, even today: the Limbourg brothers, Jean Malouel, and Jean Fouquet and his understudy Jean Bourdichon. The different calligraphies used were Gothic Textura (fourteenth/fifteenth centuries), Gothic Fraktur, Gothic Rotunda, Gothic Cursive, and Hybrida.

Classical Style

Interlacing white vines around gold initials, accompanied by parrots or other winged animals, were particularly appreciated at the end of the fifteenth century. In Italian illuminated manuscripts, initials abounded painted in the style of concise Roman inscriptions and framed by flowers, acanthus and laurel leaves, and medallions. The calligraphy associated with this style was Humanist minuscule, which strongly influenced printing presses, and the form of the letters is close to modern typography.

Illuminated Manuscripts Today

Today, illumination isn't outdated; the technique is still practiced. Certain limners create reproductions for museums, copying ancient methods. Others create superb reproductions, or work on personal ideas for clients. Illumination can be used to decorate diplomas, invitations, or family trees. It's also a lovely way of decorating to mark a memorable event, such as a wedding, a birthday, or an anniversary. Any themes and subjects are possible. Outside the context of manuscripts—which are long and difficult to create—modern limners mainly create decorative paintings with or without accompanying calligraphy. Taking inspiration from ancient manuscripts and different styles, they shed a new light on illumination and they offer the world their own compositions.

▲ *Created by the author: interlacing initials in the fifteenth century Italian style.*

Calfskin, gold leaf on gesso, medieval tempera.

 Lovers

The author's liberal interpretation and re-composition of board 55 of the Manesse Codex. Calfskin, 22-karat gold leaf on gesso (squared corners, flower hearts), on gum ammoniac (frame) and shell gold (leaves and angles), medieval tempera.

This subject was created for a wedding: we can see a scene depicting an oath of love under the Tree of Life. The sword represents protection; the dog, faithfulness. The decoration and the pictorial touches are very different from the original design.

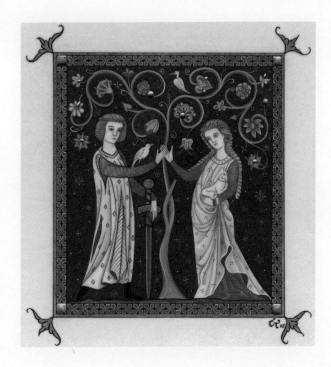

SUPPLIES AND TECHNIQUES

Basic Materials

Illumination requires specific good-quality equipment. Let's look at the basic materials that you should always have close at hand: tools, of course, but also gold, mediums, pigments, and more.

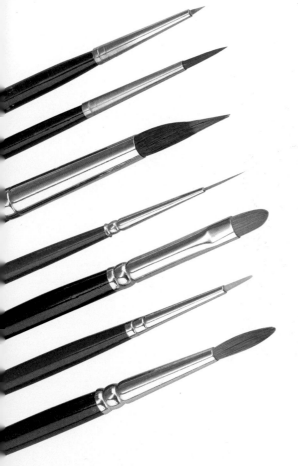

Brushes

It's important to have a range of brushes at your disposal: N°00, N°1, N°2 and N°3, for example, would be a fine variety to start with. Choose sable-hair brushes: they are more expensive but they are excellent quality. A "cat's tongue" brush (rounded tip) and a flat brush (square tip) are useful for details and blending. After using brushes, clean them in soapy water and store them flat, or, ideally, hanging with bristles down. Definitely not with bristles up!

Inks

It's possible to work on a drawing using lead pencil (2B thickness), but you can also later go over the lines with ink. For outlining a drawing with a dip pen, use India ink; airbrushing ink, which covers completely and is indelible; or add a medieval touch by using oak gall ink, which you can find in specialty stores. I work on my drawings in pencil, and I outline everything at the end with pigment of the same shade but a bit bolder than the design's color. If it's a Romanesque illumination, the outline can be done in tempera, burnt umber, or lamp black.

Dip Pens

During your work, you might have to use a pen to reproduce your pattern and for outlines. It's best to use a dip pen with a fine or extra fine metal nib. Try it out first to check the thinness of the line. Never overload the pen with ink to avoid blots on your work. Clean the nibs carefully after using them; if the ink has dried out scrape it off with a sharp knife. If you don't feel comfortable with a dip pen, use an indelible fine point felt-tip pen. When you've gained some experience, you can instead do the outlines with an extra-fine brush using black or umber tempera for more beautiful results.

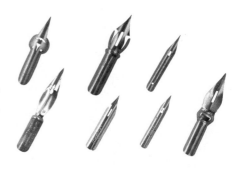

Gold

Gold is a noble material. You should choose it carefully, based on the work you want to do. You will find it in different forms: gold leaf, shell gold, or gold powder.

▶ **Gold leaf** is usually sold in books. There are two types of leaves: loose gold leaf or self-adhesive gold leaf. They're available in different colors and different thicknesses. They are very fragile and should be handled very carefully. If you are going to use loose gold leaf, you'll also need a gilding cushion, a palette, and a gilding knife. The other tool needed is an agate dogtooth burnisher for polishing gold leaf on gesso.

▶ **Shell gold** is gold powder mixed with gum arabic. Diluted with purified water, it is ideal for creating precise details, and especially for accentuating light.

The word "gilded" is only properly applied to work created with gold leaf. You can also find gold gouache in specialty stores. These paints in tubes are easy to apply, but they don't have the brilliance of real gold.

Pigments

To make your colors, you'll need a palette knife or a muller (a container with a specially ground glass base), and a glass slab, a tile, or a slab of marble or porphyry. You'll find a list of basic natural pigments starting on page 28; when mixed with a medium, they will allow you to color all your creations.

Paper and Colors

Parchment is the best surface for illumination (see page 14), but if you don't want to spend money on hide, you can easily work on paper. Choose parchment paper ("pergamenata," vegetal parchment) or the rather thick ecru "elephant hide" paper (180-gram weight, minimum). For pasting this paper, it's best to dampen it recto and verso three times with a clean sponge. After this, proceed the same as with parchment. (Warning: never sand down your paper!)

Likewise, you can choose to paint your illuminated manuscript with modern materials. It's best to work with extra-fine gouaches or watercolors, even though they don't have the same luminosity as natural pigments. You'll find more about the most appropriate paints on page 31.

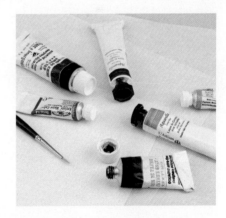

Small Details

A few other supplies will also be essential as you work: tracing paper, a square, scissors, and masking tape. Don't forget a sharp black pencil or a mechanical pencil, and a kneaded eraser.

13

The Parchment

Parchment is the best material for illuminated manuscripts. It is easier to use than ordinary paper, since it can be cleaned if it gets blotched by mistake, or even sanded if a stain penetrates the hide's pores. So don't hesitate in investing in this material—you'll find it a pleasure to handle and easy to work with.

The Characteristics of Hide

You can see two layers on the skin: the papillary layer, on the hair side, and the reticular layer, or flesh, on the muscle side. You should paint on the papillary side. On the other side, the vein grooves are visible and the surface is normally rougher. If you compose an entire manuscript, though, you will paint on both sides. Remember to make your book with the pages flesh side against flesh side and hair side against hair side (see the instructions on page 78).

Choosing Parchment

Order your parchment in a specialized store. Choose goat, kid, or calf rather than mutton or lamb, which is fattier. Goat has a rather marked grain: it is somewhat thick hide with large pores. On the other hand, calf is very smooth and fine as it came from a young animal. The "eye," scars and stretch marks are part of the parchment: they shouldn't be considered as defects. Choose your material according to the texture you feel better with, but remember that there isn't much difference

between working with goat or calf, even if the grain on goat hide is more visible. Calf hide can be confused with high quality smooth paper to the inexperienced eye. Its color varies from white (if the hide has been soaked in hydrogen peroxide) to ecru. Certain kid can be a lovely beige or gray according to the color of the animal's hair, which can make for interesting effects, particularly for more contemporary subjects.

Keep your hides somewhere cool and dry. Store them flat, under a bed for example or in a portfolio. Parchment is cut with a sharp knife on a rubber cutting board or on thick cardboard.

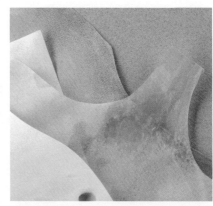

Calf, kid, and goat.

Papillary (or hair) layer.

Reticular (or flesh) layer.

Making Parchment

Making parchment is a long operation that needs particular skills. It is the result of a technique of treating the hide, developed in Pergamum, Asia Minor. Here are the principal stages of preparation.

Soaking or immersion: The hide is salted and dried and then immersed in a bath of water.

De-wooling or de-hairing: The hide is coated with a solution of sodium and lime. After a few hours the wool or hair follicle is burnt. The hide can now be rid of its covering.

Liming: The hide is put in a drum containing a lime-based solution. The solution breaks down the hypodermis as well as the fat in the dermis.

Cleaning: The hide is spread, hair-side out, on an easel and cleaned using a double handled-scraper made of slate.

Defleshing: The dermis is rid of the hypodermis and the last bits of flesh and hair.

Mounting on a frame or stretching: The wet skin is then mounted on a wooden frame. Its edges are pierced by wooden skewers, fixed to the frame by a system of cords and pegs. The pegs are turned to stretch the hide to maximum tension. It is cleaned again with a lunellum and then dried. A complete modification of the structure of the dermis takes place. The collagen fibers, interlacing in the hide's natural state, reorganize themselves parallel on the surface of the hide and in the direction practiced during drying. They arrange themselves in lamellar layers. Under the effect of damp, the fibers have a tendency to return to their original organization, causing the hide to swell: which is why the parchment should be pasted or stretched on a wooden board before painting it.

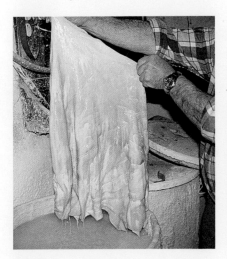

Defleshing.

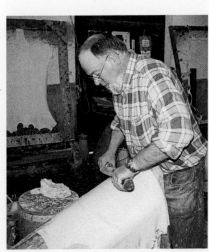

Cleaning.

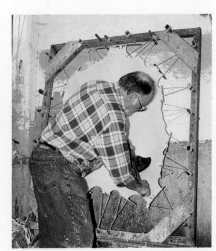

Stretching.

15

Stretching the Hide

Once you have your parchment, you should stretch it on a support. This is an essential step, because the hide is sensitive to atmospheric and hygrometric changes. If it isn't stretched on a board, it risks warping. Two techniques are possible: stretching it on a wooden board or pasting it to cardboard, a modern technique that is practical for putting your creation under glass or framing it.

Materials

- *Parchment*
- *Wooden or plywood board (8 mm thick)*
- *Bowl of water*
- *Paper towel*
- *Staples or upholstery tacks*
- *Sheet of white paper the same size as the board*
- *A utility knife*
- *Sandpaper*

Stretching on a Wooden Board

1 Cut the parchment to the desired dimensions: size of the illuminated manuscript, plus 4 inches in length and 6 inches in width. For example, for an illuminated manuscript of 4 × 6 inches, plan parchment measuring 8 × 12 inches. Cut the board, leaving a minimum margin of 1 inch around the parchment. For an illuminated manuscript of 4 × 6 inches, prepare a board that's 6 × 8 inches.

2 Soak the parchment in a bowl of water for about 10 minutes.

3 In contact with the water, the parchment softens and becomes slightly transparent.

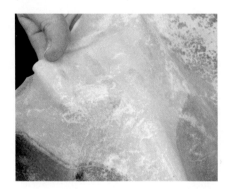

4 Dab it gently with the paper towel, working flat on a table.

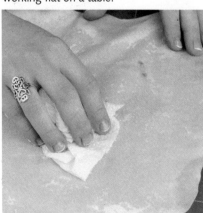

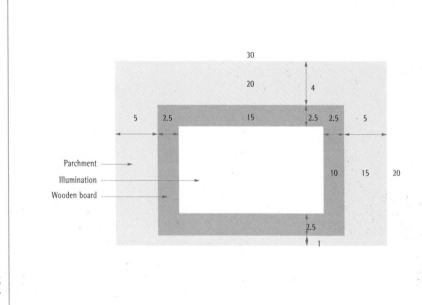

5 Tack or staple the parchment at intervals of about ⅝ inch to the edge of the board (the side where you have planned ½ of parchment to fold back over the edge of the board). The board should be centered on the length (2 inches on top and 2 inches on the bottom) and staggered on the width (⅜ inches on the left and 2 inches on the right).

7 Tack or staple the opposite edge, stretching the hide (this is why you should have about 2 inches of excess parchment: to be able to hold on to it properly while stretching). If you are using tacks, pierce the hide beforehand so that the point doesn't tear the parchment.

9 Cut the extra parchment close to the board, leaving a little surplus hide in the corners.

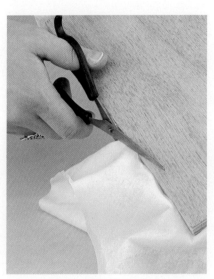

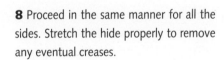

6 Place the sheet of white paper on the board to avoid the wood's tint discoloring the parchment when you are painting it.

8 Proceed in the same manner for all the sides. Stretch the hide properly to remove any eventual creases.

10 Fold the corners onto the sides of the board and staple or tack them. Leave it to dry for two or three days and then sand the surface. You won't detach the parchment until your illumination is finished, cutting it flush with the sides of the board using a utility knife.

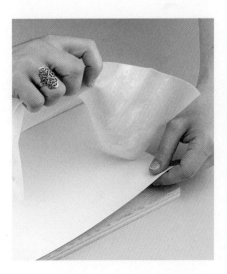

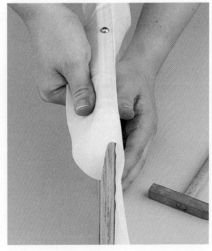

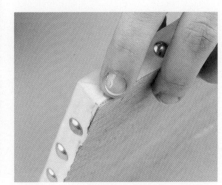

17

Pasting the Parchment to Cardboard

1 Find the direction of the cardboard fibers: this can be found by touch. Slightly bend the cardboard: you will find it suppler in one direction than in the other. The kraft stripes should be placed in the same direction as the cardboard fibers. To keep your bearings, draw a small arrow in the right direction.

2 Cut the sheet of kraft to the same dimensions as the cardboard and moisten the satin-like surface. Spread the PVA in a thin layer on one side of the cardboard, making sure to cover the entire surface, starting in the center, working in a star towards the exterior of the cardboard; don't do it the other way round to avoid accumulating too much paste on the edges.

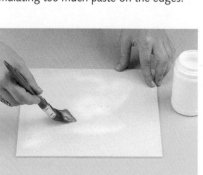

3 Place the matt side of the kraft sheet on the cardboard, the stripes should be in the same direction as the cardboard fibers. Remove any air bubbles with a damp cotton pad. Use the folding knife to make sure the kraft is properly stuck to the cardboard.

4 Turn the cardboard over. Using a light pencil draw a frame the dimensions of the parchment, making sure it's perfectly centered. Apply the starch paste inside the frame, covering the entire surface to the lines of the frame. If your parchment is thick, mix the starch paste with a little PVA glue.

Materials

- *Parchment*
- *Piece of cardboard 1/16 to 1/8 inches thick (neutral pH)*
- *Cotton pad*
- *Paper towel*
- *PVA glue (olyvinyl acetate) or white bookbinding glue*
- *Starch or flour paste*
- *Two plywood boards (or thick, clean cardboard)*
- *A weight (or heavy books)*
- *A roll of kraft paper (120-gram)*
- *Demineralized water*
- *Pasting brush*
- *Scissors*
- *Double decimeter*
- *Folding knife*
- *Sheets of glazed paper to protect the table*

From left to right: Sandarac resin, mortar, cotton pads, pumice powder, water with vinegar, sanding paper, and a scrap of parchment.

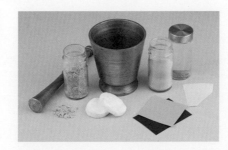

2 Place a knob of pumice powder mixed with a third of sandarac powder onto the stretched or pasted parchment. Using the scrap of parchment, hair side against hair side, sand the entire surface gently for about 5 minutes.

5 Place the dry parchment in the center of the cardboard. Stick it down using the folding knife. Work quickly to avoid the parchment getting moist and beginning to wrinkle.

Preparing the Surface

Whichever technique you have used, you have to sand the surface before starting to paint. This enables the ink and paint to adhere perfectly to the parchment. You'll need pumice-powder, sandarac resin (optional, but use it if your parchment is particularly oily or if you are going to calligraph a text), a scrap of parchment, very fine sandpaper (with a grit of between 21.8 and 18.3 microns; 500-grit, for example) to be used without water, and white vinegar mixed with demineralized water (one part vinegar to two parts water).

6 Weigh the cardboard down between two plywood boards or thick cardboard, for at least 2 hours, or overnight for large sized parchment.

1 Reduce the sandarac resin to fine powder in the mortar and sieve it.

3 Dust thoroughly with a cotton pad, then sand it along the length and width with 21.8-micron or even 18.3-micron sandpaper without damaging the surface. Never use an electric sander! Dust it again thoroughly with a paper towel or a clean dry cloth. The surface must be as soft as a baby's skin. Touch it with the back of your hand rather than with your fingertips. It's also possible to clean the surface with a cotton pad slightly moistened with a mixture of water and white vinegar, to remove any residue. Be careful not to overmoisten the parchment (wring your cotton out well). Leave it to dry before starting your design.

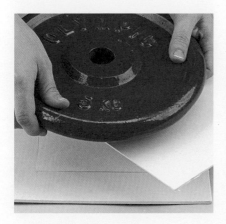

19

GILDING

The "Binder"

Without any doubt, it's the use of gold that gives an illuminated manuscript its richness and appeal. To fix it to a surface, you must first apply a "binder," mordant, gilding paste, or gesso that can be made according to either ancient or modern techniques. Laying gold leaf on gesso gives it relief and is very brilliant; laid on a mordant or gilding paste it is flat and sometimes the parchment's grain shows through. Choose the technique that matches the style of your illumination best.

Medieval Techniques

Mordant made with garlic juice

Easy and economic, this technique is very ancient. Crush a large clove of fresh garlic in a wooden mortar. Extract the juice, strain it through very fine mesh, and then apply it with a brush in one layer on the parts you want to gild. Spread it out in a fine layer, or else the juice won't dry. When it is shiny and dry to the touch, apply the gold leaf as indicated in pages 24 to 26. Touch it only very lightly to avoid leaving fingerprints. This mordant is more fragile than the others. The gold can't be burnished.

Mordant made with gum ammoniac

This technique is also ancient. Gum ammoniac is made from the resin of a plant that grows in Iran or North Africa. It comes in the form of small, beige-colored lumps. You'll have to prepare it yourself because only raw gum crystals are sold commercially. Warning: the gold isn't burnished on this surface (see page 26).

1 Place a soup-spoon of gum ammoniac in a small glass jar. Cover it with demineralized water and a spoonful of white vinegar. Leave it for 24 hours, stirring it from time to time.

2 The following day, filter it through thin fabric (a piece of pantyhose for example) or a tea strainer. Press the residue to extract all the gum. Add two or three drops of gum arabic to the milky liquid and one or two drops of honey water (see page 32).

3 Apply the mordant to the surface to be gilded, in one smooth movement, without going over it again with the brush to avoid leaving traces. Apply a drop and spread it a little. Don't hesitate to frequently recharge the brush with gum.

4 Spread the gum towards you, placing the brush parallel to the edge of the pattern. Apply it in a regular layer, without brush marks: you should avoid going back to fill missing places once the surface has begun to dry. If the binder is applied irregularly, quickly do a second layer along the whole piece, trying to level the thickness. Leave it to dry for about 15 minutes and then apply the gold leaf.

Gesso

This was the technique used in the Middle Ages to give a relief: one "sits" the gold on this material made from honey, fish glue, plaster or precipitated chalk, white lead, and Armenian bole. You'll certainly find plenty of other recipes, but this one seems ideal no matter the weather or the hygrometric level. If it is really hot, add a dose of honey water and a dose of fish glue. The gesso is polished with an agate: the gold is much more brilliant and can be engraved. It is a more difficult procedure to make and to apply than mordant.

Recipe

I use a tiny spoon that holds 0.5 ml (about 0.01 ounces) and has a bowl that measures about ⅜ inch across; they're usually used in cosmetic making or candymaking.

- 16 measures of precipitated chalk (base of the gesso)
- 2 measures of white lead (for a homogenous consistency)
- 4 measures of Armenian bole (for the color)
- 6 measures of honey water (to make the paste supple and to stop it from drying out and cracking)
- 4 measures of fish glue (for adhesion)
- A few drops of spring water (for a rather fluid substance, like blended yogurt: prepare a rather liquid gesso if you want to keep it for more than a few days, up to two or three weeks).

Left to right: Precipitated chalk, Armenian bole, white lead, a syringe without a needle (for measuring), and a lidded jar for mixing the dry ingredients.

Preparation

1 Sieve the three dry ingredients (precipitated chalk, white lead and Armenian bole) and put them into a lidded jar and thoroughly shake them. Put the mixed powder onto a ground glass slab, add a few drops of demineralized water and grind it with a muller or palette knife.

2 After about 20 minutes you'll obtain a homogenous, creamy paste: progressively add the "wet" ingredients. First add the honey water, grind the paste again, and then add the fish glue. To get the right dose of fish glue, use the handle of a paint brush rather than dipping the measuring syringe into the glue.

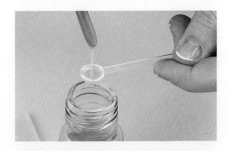

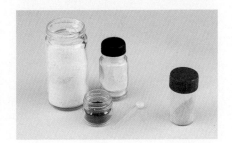

3 Mix the paste for at least half an hour on the ground glass slab, using a muller or palette knife.

4 Add a little demineralized water from time to time to keep its fluid, creamy consistence. You should no longer see fine white "threads" on the surface (this is the white lead which takes time to combine with the rest).

5 Leave it in a tightly closed jar to settle overnight, to allow any bubbles to rise to the surface. The next day, if there are still bubbles on the surface, burst them with the tip of a paintbrush handle with earwax on it (yes—real earwax!), which will "suck out" the bubbles.

Tip

Gesso can be preserved for about 3 weeks. If it thickens add two or three drops of spring water, stir it gently with a paintbrush handle, and leave it to settle for an hour or two before applying the gold (see pages 24 to 26). To avoid wasting it exercise with PVA glue (see page 23), which has the same consistency.

Application

1 Only draw the outline of the gilding, without stopping to do the interior details of the pattern: as you are going to sand it, you'll damage your drawing. The full-sized pattern can be found on page 49.

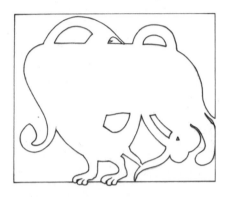

2 Hold the jar of gesso in one hand, the brush in the other. Don't hesitate to load the brush; you need enough gesso to be able to spread it without differences in level.

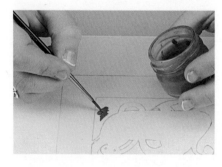

Tip

If you accidentally get a drop of water on the dry gesso, gently remove it with the corner of a paper towel. Smooth it with a clean paintbrush. Leave it to dry, then sand it again. If a drop falls on the gold leaf, proceed in the same way. Sand the leaf and apply a new one.

22

3 Put drops side by side (the drop will stay on the tip of the brush for a moment or two before dropping). Spread it over the surface without touching the parchment with the brush. If you haven't got enough gesso when you reach the border, add a drop and spread it. You should have a rather pronounced relief; as it dries out the gesso will flatten. Moreover, you will be sanding the surface down later.

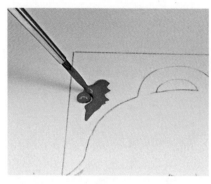

4 Smooth out the edges on all sides to remove any "lace." Only the tip of the brush should be in contact with the gesso. Keep the brush perpendicular to the edge of the pattern.

5 Cover the surface in one piece without stopping to avoid irregularities and differences in thickness. If you miss bits, load your brush and fill in the gaps. Each part started should be properly finished before starting on the next one.

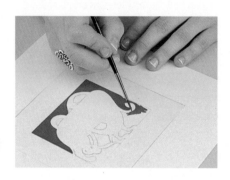

6 Dry completely, at least overnight. Carefully sand the gesso with small pieces of sandpaper with grits of between 21.8 and 18.3 microns (500-grit, for example) until the surface is perfectly even, without any scratches. Burnish it with the agate burnisher. Dust off with a lint-free paper towel. Clean off the red powder on the parchment with a slightly damp cotton swab, without touching the gesso. To clean up irregularities on the edges, pass a clean damp brush several times over the areas that have small skips in the color, until the material blends smoothly to cover them. Let dry, then lightly resand those areas.

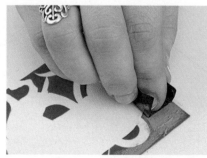

Modern Techniques

Gilding Paste

A modern product, gilding paste gives results close to those obtained using gum ammoniac. It is very liquid acrylic glue, usually sold on the shelves alongside sheets of oxidized copper used for decoration. It is ready to use and is applied in the same way as gum ammoniac. As it is white, it's better to add a drop of ink so you can see it. Gold is yellower and more intense if the base is a warm color, so add a couple of drops of red India ink if you are using yellow gold leaf, or blue if you are using white gold leaf or silver leaf. Warning: the gold leaf is not burnished on this surface.

PVA Glue

This is white polyvinyl acetate, which will give you interesting results, close to gesso but with less brilliance and smoothness. Buy bookbinding glue, not glue for wood! Generally, a single layer of gold is enough with this surface. Once again you don't burnish the gold on this surface.

1 Pour the glue into a small jar. Add a few drops of red ink. It doesn't really matter how much, as it's only to color the glue.

2 Add 3 or 4 drops of demineralized water to make the glue more liquid. Stir without letting air bubbles form. The base should have the same consistency as blended yogurt.

3 Apply it in the same way as medieval gesso; however, be careful: you can't sand it, so the application should be perfect the first time.

4 Any modifications (filling in gaps, correcting the borders, etc.) should be done while the glue is fresh, there's no going back over it once it has started to dry out. If it has been applied incorrectly, wait until it is completely dry and remove it with a utility knife before starting again.

5 In a pointed pattern, spread the glue towards you, using only the tip of the brush. You should have enough base so that the thickness is the same everywhere. If you go over the edges, immediately remove the surplus with a small scalpel.

6 If you have some glue left over, store in an airtight jar and add a little water if it starts getting thick.

The Wrong Way

Going outside the lines and creating "lace."

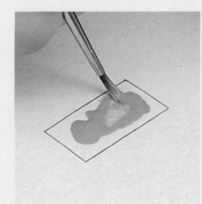

Squashing the brush into the glue and making hills and valleys.

Placing Gold Leaf

Gilding with gold leaf is without doubt the best way to illuminate a page. Gold leaf is usually sold in booklets of leaves, and the leaves measure about ⅜ inches square. It comes in different colors: yellow gold, light yellow, lemon yellow, green, pink, red, white… You can also use silver leaf, but it oxidizes and blackens with time. As a beginner, your best choice is self-adhesive gold leaf.

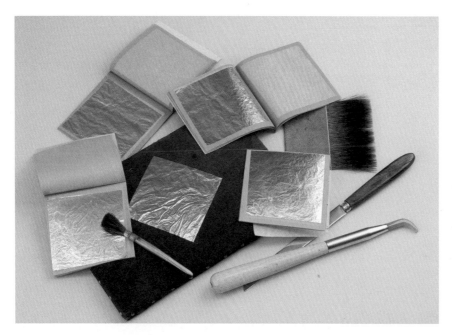

2 Blow hot air through a small paper tube of about 5 mm diameter (don't use a plastic straw because of condensation) to humidify the gesso or mordant.

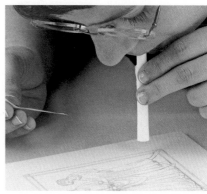

Self-Adhesive Gold Leaf

Self-adhesive gold leaf is "stuck" to tissue paper, which allows it to be manipulated with your fingers and cut with scissors. However, be careful to only touch the tissue paper and not the gold leaf, which tears easily. Only the gold should be in contact with the gesso or the mordant.

1 Cut a piece of gold leaf a little larger than the surface you want to cover.

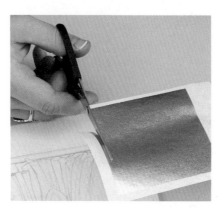

3 Apply the piece of gold leaf immediately. Press firmly on the tissue paper with vertical movements and then remove it. Dust off the surplus gold with a gilder's mop (see page 26).

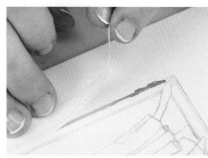

Loose Gold Leaf

If you feel comfortable working with it, you can buy loose gold leaf. In this case you'll need a gilding pad, a gilder's knife, and a gilder's tip. Beware of drafts!

Preparation

1 Open the book to the first gold leaf, keeping it in place with the tissue paper or book cover.

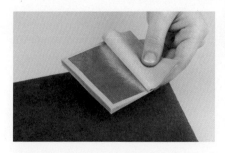

2 Turn it delicately onto the cushion and open the book progressively to free the gold leaf.

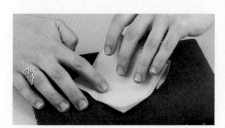

3 Press down with your finger and place the entire leaf onto the cushion.

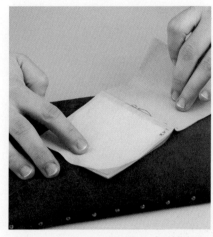

4 Lift the book carefully and close it properly. Keep it in a flat box. If the leaf is wrinkled, replace it using tweezers or the gilder's tip.

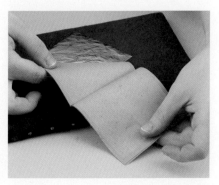

5 Cut six equal-sized bands along the width and then on the length to obtain 36 small squares. The knife's movements should be very limited: you're not cutting a slice of bread! So proceed with small back and forth movements, leaning the knife slightly to the left and then to the right.

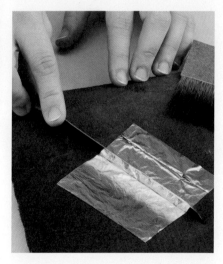

Tip

You can find gold-colored ink and gouaches in arts stores that give good effects, but never substitute them for gold leaf. Don't use copper leaf, which is cheaper but harder to apply and it quickly oxidizes.

Application

1 Run the gilder's tip over the greasy parts of your face or hair (if you have dry skin, squeeze a little face cream into the palm of your hand and run the tip over it). Don't touch the gold leaf with greasy fingers. Blow gently onto the gesso or mordant to dampen it.

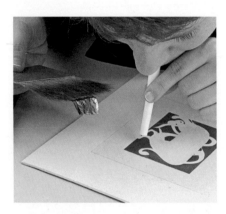

2 Gently position the gilder's tip onto a small square that you can easily transfer onto the gesso or mordant dampened by your breath.

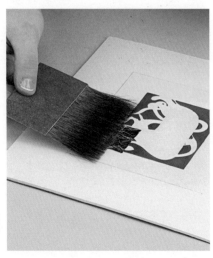

3 Cover the leaf with tissue paper or tracing paper and press firmly on the gold leaf. Always do vertical movements so that you don't leave your fingerprints on the gesso.

4 Continue in the same way for the entire surface.

5 Dust off the surplus gold with a gilder's mop or a large squirrel hair watercolor brush.

Burnishing

You can burnish your gold leaf ONLY if it has been applied onto gesso, using an agate burnisher. The surface will become very brilliant and reflect almost like a mirror. Choose a "dog's tooth" (curved) agate burnisher, with a large stone. Warm it first by rubbing it energetically on a piece of silk (or cotton) and then burnish the gold leaf carefully. If there are any imperfections, sand the gesso again so that there are no lumps and bumps, however small, and so that the agate slides smoothly over the surface. Keep the agate warm while burnishing the gold leaf, and start by gently running the burnisher over the surface. Apply pressure (but not too much) progressively until you have a shining brilliance. This phase is carried out between 15 minutes and an hour after placing the gold leaf.

Using raised gesso also allows for design elements to be added to the gold surface. Patterns or images can be made by pricking dots, engraving, or gold tooling, where a design is heat-impressed.

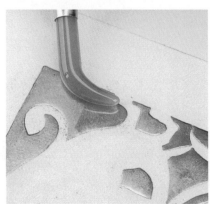

Shell Gold

Shell gold is the result of reducing gold leaf to powder. This procedure, called chrysography, was particularly appreciated in the fifteenth century for highlighting plants and garments.

First Method

1 Place a booklet of gold leaf in a mortar. Add a soup spoon of honey and a little water so that the leaves don't blow every which way. Grind.

2 Spread the mixture onto a porphyry board and grind it with a muller and coarse salt until the gold leaf is reduced to tiny particles. Add more salt as soon as you don't feel its abrasive action on the board.

3 When the gold is very fine (after about 2 hours of grinding), rinse it: place the paste in a small jar and let the gold sink to the bottom; empty the salty water carefully and repeat the operation until all the salt has been removed.

4 Don't add more than 2 drops of fish glue to combine the gold powder. Add white wine and 3 or 4 strands of saffron and keep it in a small tightly sealed jar. Shake it regularly to avoid any sediment. When you want to use the gold, remove the wine, which you can use to rinse your brush.

Second Method

1 In a small porcelain saucer, crush 12 leaves with your finger, adding an inch-in-diameter dollop of ready-to-use gum arabic.

2 "Tap" the leaves energetically to reduce them to a fine paste. This operation takes 4 or 5 hours; good luck!

3 Leave it to dry. Add a few drops of demineralized water when you want to use it. This method produces finer gold, more agreeable to work with for highlighting work.

4 It is better to prepare gesso under powdered gold: grind Armenian bole with fish glue diluted to 70% (70% demineralized water and 30% of ready-to-use fish glue) and a few drops of honey water. Apply a layer in all the areas to be gilded. Then delicately apply the damp gold powder with a brush, without touching the gesso (work carefully only using the tip of the brush). You should do 2 or 3 fluid layers. Leave it to dry completely between each layer and burnish the last layer with an agate stone.

Tip

You can replace shell gold by gold mineral powder, a mixture of mica and mother-of-pearl: this is applied without gesso. The result is more artificial, but you won't have to spend hours grinding gold leaf!

USING COLORS

Pigments

Pigments are colors reduced to powder, generally with animal, vegetable, or mineral origins. However, there are also chemical colorants that offer good shades. The palette of colors in the twelfth century was relatively minimal: you'll need cinnabar or vermillion, lapis-lazuli or azurite, verdigris, yellow ochre, red ochre, lamp black, and cerussite or titanium white (easier to find). In the descriptions below, an asterisk (*) is used to indicate the colors that were used in the Middle Ages.

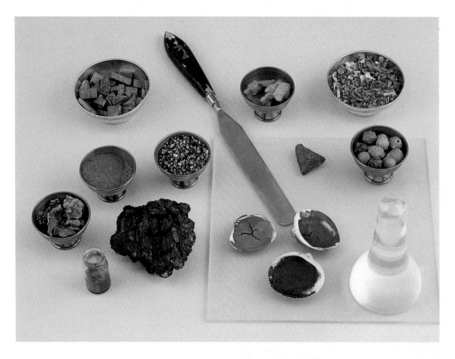

White

▶ **Cerussite*:** basic lead carbonate. It is also called white lead. You can make it yourself; Place two wooden blocks in a plastic bowl. Add white vinegar without completely immersing the blocks. Add small pieces of white marble (or marble powder). Place a lead board on the blocks, making sure it doesn't touch the vinegar; seal the bowl tightly, wrap it in aluminum foil and place it in the sun or on a hot radiator. After a few days, white powder forms on the lead board: you just have to scrape if off. Wear gloves and a protective mask when manipulating this pigment. Use white lead as an undercoat for faces (pale-skinned faces in particular) with a touch of green earth for shadows.

▶ **Titanium white:** Titanium dioxide. Created in 1915, it covers better than white lead. Ideal for highlighting, you can find it in any art store. Avoid zinc white, which lacks opacity. If you want to glaze or give transparent effects, use white lead.

Ochre

Ochre comes from sedimentary rock composed of iron oxide crystals, amorphous, clay and quartz, and sometimes manganese oxide (brown ochre).

▶ **Light yellow ochre*:** interesting as an undercoat for plants. Citrine yellow ochre is also good for this use.

▶ **Yellow ochre*:** clay rich in limonite or in iron oxide more or less hydrated.

▶ **Havana ochre*:** a warmer color than yellow ochre, it is interesting as a use for skin-color (tanned).

▶ **Burnt sienna*:** heated earth pigment from Italy.

▶ **Burnt umber*:** manganese-rich ochre from Umbria, Italy. Some are less dark than the one presented in the shade chart.

▶ **Red ochre*:** hematite-rich clay. Yellow ochre heated to a temperature over 482°F takes on a red tint.

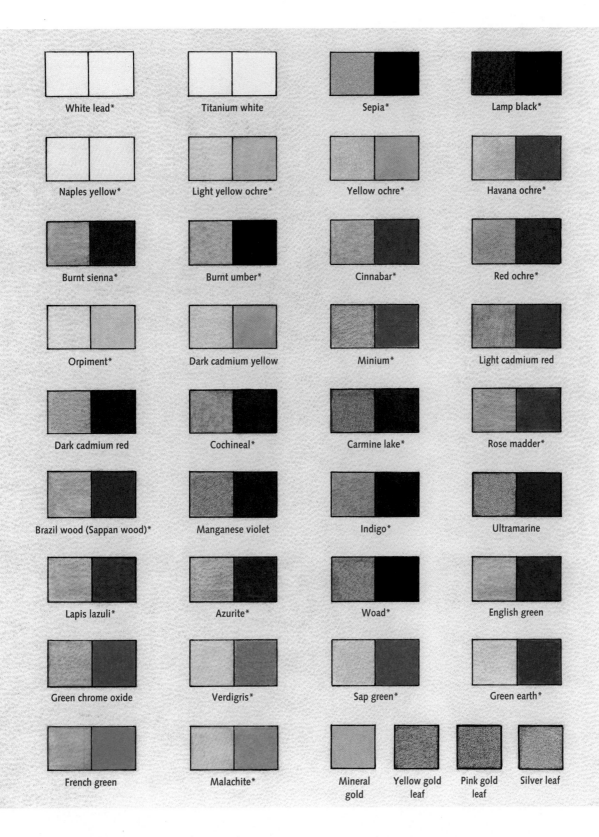

White lead*	Titanium white	Sepia*	Lamp black*		
Naples yellow*	Light yellow ochre*	Yellow ochre*	Havana ochre*		
Burnt sienna*	Burnt umber*	Cinnabar*	Red ochre*		
Orpiment*	Dark cadmium yellow	Minium*	Light cadmium red		
Dark cadmium red	Cochineal*	Carmine lake*	Rose madder*		
Brazil wood (Sappan wood)*	Manganese violet	Indigo*	Ultramarine		
Lapis lazuli*	Azurite*	Woad*	English green		
Green chrome oxide	Verdigris*	Sap green*	Green earth*		
French green	Malachite*	Mineral gold	Yellow gold leaf	Pink gold leaf	Silver leaf

The colors followed by an asterisk (*) were used in the Middle Ages. On the left, the color is applied as transparent; on the right, it is applied flat in two to four layers.

Yellow

▶ **Naples yellow*:** a mix of antimonite and lead antimonite. It was mostly used in fine oil colors between the seventeenth and nineteenth centuries. It is very hard to find nowadays (usually imitations of cadmium yellow and white).

▶ **Orpiment*:** arsenic sulfide mineral. You should be very careful manipulating this pigment. It was first used during the Middle Empire, probably imported from Urmia, Iran. If you can't find it you can replace it with chrome yellow or light Indian yellow. Avoid the too bright canary yellow!

▶ **Dark cadmium yellow:** cadmium sulfide. It is a lovely golden yellow, better than primary yellow, which is a bit too bright. Mixed with light cadmium red, it results in good orange or brick-colored shades.

Pigment Toxicity

Certain pigments such as white lead (used in fabricating gesso, for example) or orpiment are very toxic and should be handled with caution. You should wear gloves and a mask to avoid any contact with your eyes and skin. Store your pigments in tightly sealed jars, away from the light and out of children's reach. Wash your hands thoroughly after using them. Don't hesitate to follow the manufacturers' instructions, which are clearly marked on the packing.

Red

▶ **Cinnabar*:** natural mercury sulfide. You can find it raw in mineral markets, notably in Spain where there are large mines (in Almaden, for example). If you buy it ready-to-use, it will probably be chemically produced from mercury and sulfur: therefore it is very toxic.

▶ **Minium*:** orange-red pigment obtained from cerussite. It has been in use since the Roman Empire.

▶ **Light cadmium red:** cadmium sulfoselenide. With dark cadmium red, it's one of the most agreeable pigments to work with due to its suppleness, its quality of easily mixing with mediums, and its resistance to light.

▶ **Dark cadmium red:** cadmium sulfoselenide. Pure, it turns burgundy, almost brown when dry. You can add a drop in light red to obtain a lovely India red.

Black

▶ **Sepia*:** ink that squids release into the sea when they are in danger. Its tint is black-brown.

▶ **Lamp black*:** black obtained by the combustion of oil. Make it by burning a natural wax candle in a varnished jar. Scrape the sediment off the bottom of the jar. You can also use black iron oxide or black from charring desiccated grape vines (carbon black).

Violet and pink

▶ **Cochineal*:** carmine or purple produced from crushing female cochineal insects. Crush the cochineals in an electric blender and soak them in a sodium carbonate solution. Boil the solution and filter it through a piece of pantyhose when it reaches a thick syrupy consistency. Add a little alum (which will fix the color) and bring it to the boil again; use a skimmer to recuperate the foam that forms on the surface (let the substratum drip through a piece of cheesecloth): this is called coagulum. A soup spoon of cochineal insects produce a flat cake of coagulum of about ⅜ inch in diameter. Make little discs and leave them to dry out of the sun. You can then crush the pigment with your medium.

▶ **Carmine lake*:** made from cochineal insects, this "lake" pigment is redder than coagulum. It is fabricated in Albi, France.

▶ **Rose madder*:** Rubia tinctorum, also called dyer's madder. It is a Mediterranean herbaceous plant whose roots are used.

▶ **Brazil wood (Sappan wood)*:** made from the trunk and the large branches from a tree in Sri Lanka; reduced to powder and mixed with alum it results in a pink or amaranth color. Sadly it eventually dulls.

▶ **Manganese violet:** ammonium manganese pyrophosphate. It is a clearer and more light-resistant color than its forerunners (violet wasn't used in the Middle Ages: purplish colors were duller).

Blue

▶ **Indigo*:** extracted from Indigofera tinctoria, a tropical plant found in Asia. The plant's leaves ferment in water producing blue mud that is then boiled. Once filtered, the substance is pressed and conserved in blocks.

▶ **Lapis Lazuli*:** in Persian this means "blue stone"; it is a semi-precious stone, feldspathoid silicate mineral. You need to remove the veins of calcite and pyrite (in an enamel oven for example), grind the stone and decant it to extract the pure ultramarine. You can buy it ready-to-use, but it is rather expensive!

▶ **Azurite*:** ground copper mineral carbonate. It was used in Egypt dating back to the 4th dynasty and can be found in the Sinai or in the Eastern Desert, or simply in mineral markets. Azurite is a lovely crystal not to be mistaken with malachite, its close neighbor.

▶ **Woad*:** extracted from *Isatis tinctoria* plants, cultivated in Lectoure, France. It is also found under the name of "glastum."

▶ **Ultramarine:** a synthetic pigment created by Guimet in 1826. Chemically, it is close to its natural model, lapis lazuli. It is a very vivid pigment that I wouldn't advise using pure. Add a little white or Prussian blue or even indigo to dampen its "loud" effect.

Green

▶ **English green:** dark green tending slightly towards blue when lightened with white.

▶ **Green chrome oxide:** with a little white, you can obtain a superb almond green.

▶ **Verdigris*:** copper acetate. It is made along the same principle as cerussite, but without marble in the vinegar and with a copper board. It is a harsh pigment after a few years on paper or parchment.

▶ **Sap green*:** extracted from buckthorn berries. In the past, it was preserved in animal bladders.

▶ **Green earth*:** natural ochre from Verona, Italy.

▶ **French green:** an intense green, interesting as an undercoat for highlighting grass or certain plants.

▶ **Malachite*:** natural copper carbonate. You can find it alongside azurite in mineral markets. The stone grinds easily in a mortar.

Paint in Tubes

If you prefer to use ready-to-apply paint, choose gouache or, better, tubes of watercolor. Examples are extra-fine Linel gouaches, or Winsor and Newton watercolors. Daniel Smith manufactures 36 of its PrimaTek watercolors from natural pure pigments, including amethyst, amazonite, azurite, malachite, lapis lazuli, and many others, which makes these ready-to-use paints the most accurate substitute for pigments.

Mediums

Mediums are the substances used to turn powdered pigments into paints, thereby fixing them to the parchment, as water alone isn't sufficient. There are several recipes for mediums, which give paints specific particularities (consistency, viscosity, adhesion, luminosity, etc.). The following are ancient and give beautiful results.

Medieval Soft Distemper

This is a very economical recipe. When ground with distemper, the pigments will dry out; you can wake them up with a little water, the same as you would with water-color blocks.

Preparing gum arabic: combine one part loosely ground gum and two parts demineralized water. Leave it to soften for 24 hours, and then heat it in a bain-marie. Filter it through a piece of pantyhose and preserve the solution in a jar, adding a few drops of clove essence or preserving agent. You can also buy it ready-to-use (which means no bad smells!).

Preparing glair: beat egg whites until stiff (4 egg whites for 6¾ fluid ounces (200 ml) of distemper). Place them in a sieve over a deep bowl and let the albumen drain out. After about an hour, recuperate the liquid in the bowl.

Recipe
- 10 measures of gum arabic
- 7 measures of glair
- 2 measures of honey water

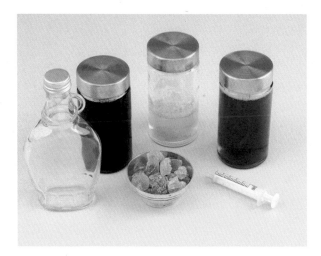

From left to right: Tightly sealed bottle for the mixture (all the ingredients), 35% diluted gum arabic, raw gum arabic crystals, egg white, honey water, and a measuring syringe.

Preparing honey water: pour 2.2 pounds (1 kg) of honey into a saucepan and bring it to the boil, avoiding large bubbles: the honey just needs to simmer and a yellow froth forms on the sides of the pan. Remove the froth. This operation can take from 30 minutes to an hour: stop before there's no more honey in the pan, when the froth becomes more fluid and more transparent. Add 1 quart (1 liter) of water and reduce it over a low flame until you have the same proportion as at the beginning (so that you can refill the honey jar). The honey is liquidized and all impurities have been removed. Add a preserving agent and store it in the fridge.

Tip

If your illuminated manuscript is going to be handled and isn't intended to be put in a frame under glass, you can prepare an undercoat. Dilute fish glue in demineralized water (0.88 ounce [25 g] of glue to 2.25 fluid ounces [75 ml] of water). Add a small spoonful of sieved precipitated chalk. Mix well without shaking. Apply a thin layer of the solution on all the zones you are going to paint. Leave it to dry completely.

Egg Yolk

Egg yolk is an ancient medium, mainly used for icons and wood-painting. It is little used in illuminated manuscripts, but it is a simple technique for beginners—and easy to find!

1 Separate the yolk from the white. Place the yolk in your hand and delicately dab it with paper towel.

2 Make a small hole in the yolk and let it run into a bowl, holding onto the membrane. Add the same amount of demineralized water or white vinegar and a couple of drops of preserving agent (or clove essence that you can find in drug stores). Egg yolk can be kept for a week in a tightly closed jar in the fridge.

3 Add a couple of drops of it to your pigments and apply them in thin layers. Warning: only use a little pigment at a time because once it has dried out, it can't be reused, so you'll have to prepare fresh pigment each time.

Grinding Pigments

For this operation, you will need a ground glass slab or a porphyry board (that you can buy from a marble mason), a muller, and a palette knife. Prepare your colors one after the other.

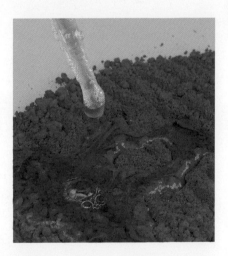

If you have decided on pigment with egg yolk: place a dose of pigment onto your board and progressively add between 2 to 5 drops of egg yolk, according to the grain size and the quantity of pigment. Grind it with the muller or the palette knife in circular movements. Scrape up the paint (which

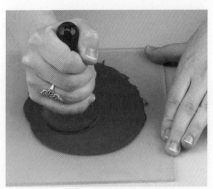

will have the consistency of blended yogurt) with the palette knife and put it into a plastic or porcelain palette.

If you have decided on medieval soft distemper: use a well-filled soup spoon of pigment. Add 3 ml of distemper (adapting it in function to the grain size and the quantity of color desired). Mix the color with the distemper using the palette knife, and then grind it with the muller until the paint is fine, smooth, and supple.

Preserve each color in small porcelain bowls, shot glasses, or small shells. These colors, once prepared, can be kept for several months; keep them away from light when you aren't using them.

Applying Color

In the past, certain limners were specialized in initial painting, others in faces while still others excelled in painting flowers or garments. Today, you'll have to try all the styles! Here are the basic principles and a few tips for beautiful results.

The Right Technique

The colors should be applied in successive thin, almost transparent layers. Leave each layer to dry for a few minutes before starting on the next until you reach the desired opacity.

1 For a lovely flat tint, start with an even, well watered-down undercoat, avoiding leaving brush marks as much as possible.

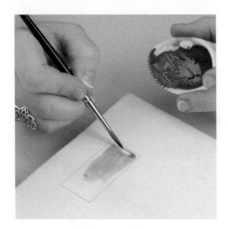

2 Leave it to dry and then do a second layer with a little more pigment, but still as fluid. Paint towards you, parallel to the edges being careful not to go over the borders.

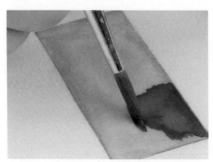

3 Some colors need between 2 and 4 layers before they are regular; no brush marks or irregularities should be seen on the surface.

Tip

Don't work with too thick or too dry paint or numerous irregularities will appear immediately.

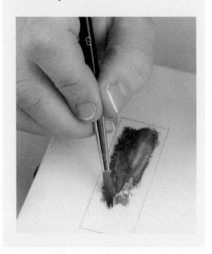

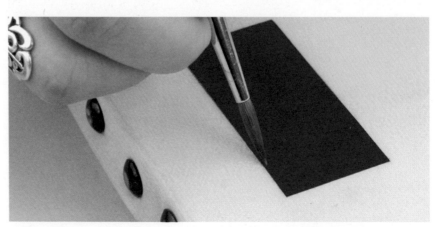

White Highlights

Use the finest brush you have, paint towards you and lift the brush at the end of the line. The paint should be fluid enough to work in a single movement, but thick enough to be seen properly.

If you get the same line as above, it means your paint is too dry.

Loops and Circles

To create a loop or a circle, proceed in two or three steps in a way so that you are always painting towards you, like the ductus in calligraphy.

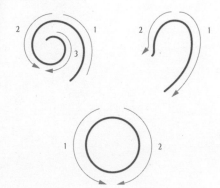

The Main Steps

After having applied the gesso on the areas to be gilded, apply the gold leaf. Do the layers of paint: the undercoat should be fluid and transparent, the others denser but still rather liquid. Paint in the shadows with a darker tint, the lights with the same color but lighter and blend them to soften the transition areas. Finish with the white highlights, the small patterns which refine and add light to the pattern. Lastly, outline the contours of the drawing, either tone on tone (a little darker than the subject), or black or burnt umber; they should be very fine to avoid overloading the pattern.

Applying the gesso.

Placing the gold leaf.

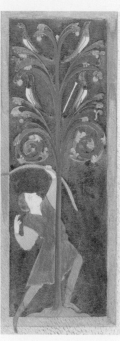

Applying the undercoat.

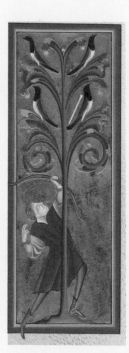

Applying the shadows (relief work).

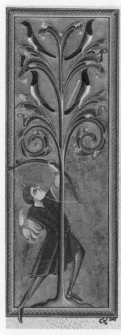

Applying the white highlights and outlines.

35

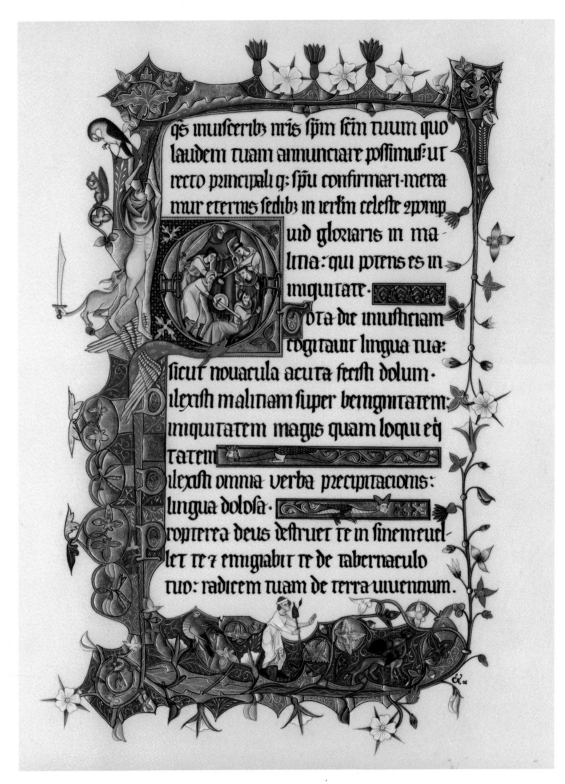

▲ **Ormesby** *(fourteenth century)*

Reproduction of a folio from the Ormesby Psalter (England, ms. Douce 366). Goatskin, gold on medieval gesso, and medieval distemper.

PROJECTS, STEP BY STEP

The patterns you will find on the following pages will guide you step by step in the discovery of illumination. Little by little, you'll become familiar with the different techniques presented in the preceding pages.

Each of these compositions gives you the chance to work on a particular aspect of illumination: manipulating gold leaf, applying it according to medieval or modern methods, creating geometric background patterns, working on the relief of faces… Soon you will have explored all the secrets of the art of illumination!

After the projects, there is a gallery of works done by limners of different epochs and styles: friezes, initials, pages richly adorned in Bible scenes or fabulous animals. These compositions demonstrate the diversity of the subjects that were captured in illuminated works during the peak of the art's popularity, and that same diversity of subjects is used by modern limners.

Afterward, taking inspiration from these examples from the masters, you, in turn, can create your own scenes—or even your own manuscripts—and make gold sparkle however you desire!

THE INITIAL C

Materials

Goatskin stretched on wood
Dimensions of the work: 3⅛ × 3⅛
inches
Pigments:
- *Titanium white*
- *Indigo blue*
- *Ultramarine*
- *Dark cadmium yellow*
- *Dark cadmium red*
- *Ercolano red*
- *Green chrome oxide*
- *Lamp black*

This initial is taken from the *Book of Sentences*, composed by Pierre Lombard in Paris around 1170. Its colors are different from the original, which had been gilded in gold leaf. There is nothing to stop you from interpreting it as you choose. Contrary to certain initials in that epoch—the artists often used an abundance of vine shoots and bestiaries—it is a rather simple pattern, chosen to familiarize you with the material and the pictorial subject. The intersections of the stems are easily seen; therefore you won't get lost in the drawing as you would with Celtic interlacing.

The pattern supplied here is back-to-front: all you need to do is to trace it once. This is the same for all the patterns in this book. In the same way, you can create the following patterns on other materials and using different colors than those suggested here.

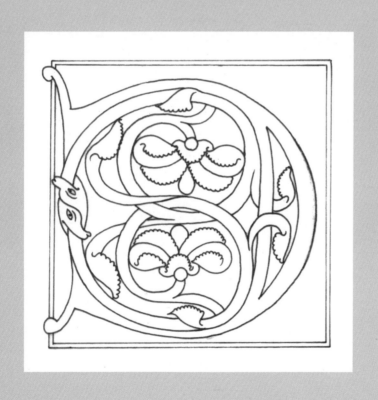

1 Trace the initial with a mechanical pencil with a point of 0.5 or 0.7 mm. Copy the pattern with firm, regular lines: the drawing on the tracing paper should be very clear and precise. Be careful of the coherence of the pattern, notably the interlacing stems and the fineness of the flowers' "lace."

2 Turn the tracing paper onto the center of your parchment, checking the margins with a ruler: the pattern should be perfectly centered. Go over all the lines to reproduce them onto the surface, in the same way as a decal.

3 Go over the pattern with a dip pen. Work slowly being careful not to put your hand in the wet ink and don't miss any details! Leave it to dry. You can also use an ultra-fine pen with India ink, or you can leave the outlines in pencil and do them at the end using a brush and black pigment.

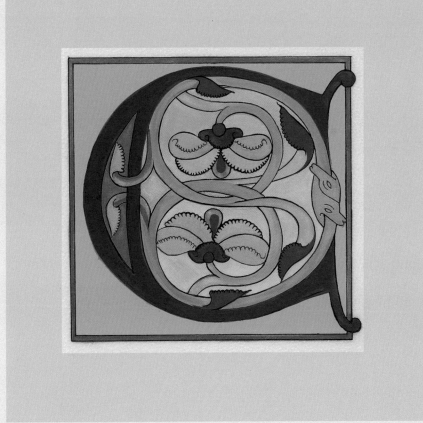

4 When you start with the colors, begin with a very fine watered-down undercoat, without leaving brush marks (see page 34). Around the initial and flowers in the center, apply a layer of green chrome oxide mixed with a touch of white. For the dark blue, use indigo enriched with ultramarine and a point of titanium white. For the light blue, add white to the dark blue. The animal heads and the flowers are dark cadmium yellow. The peach tint is obtained with Ercolano red enriched with white. The color in the center of the flowers and certain leaves is a mixeture of Ercolano with a small quantity of dark cadmium red. By adding white you will obtain a pink tint. Remember to wash the brush thoroughly each time you change colors.

5 Do the shadows in the hollows or concaves, and then highlight the extremities of the edges of the flowers and the convex part of the stems in white. In this composition, there isn't any blending or gradation: shadows and lights are created by successive fine bands, from the darkest tint to the lightest, following the curve of the pattern.

6 In the case of a stem in an "S" form, the shadows and the lights "cross" each other. The shadows lose themselves in the outline and the white crosses the stem to continue along the convex part.

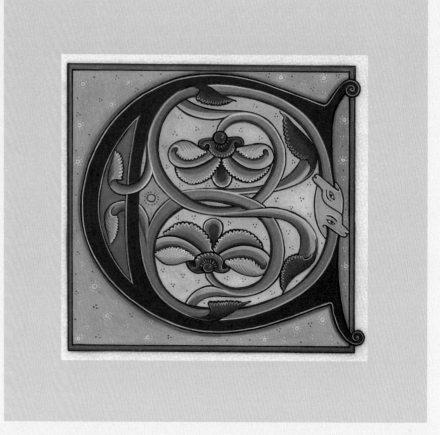

7 Load a dip pen with white paint and do small dots here and there on the green background. Do the same on the light yellow background, using red paint. Do the outlines again if necessary to base and assert the drawing: the outlines shouldn't be too thick. It's often hesitation that causes you to make mistakes.

FLOWERY FRIEZE

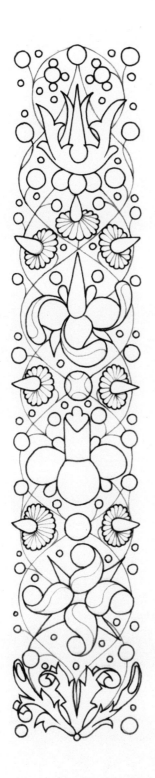

This second work is a little finer than the initial. Its application of solid colors and fine white highlights is key. For this creation, gold can be set on a gum ammoniac mordant or on a water mixture for the petals and PVA glue for the small balls. The gold relief adds weight to the subject. This composition is inspired by a frieze reproduced in an English work by Carol Belanger Grafton: *Treasury of Illuminated Borders in Full Color*. The origin of the frieze isn't known.

Materials

Dimensions of the work: 1⅜ × 7¹⁄₁₆ inches
Gold on gum ammoniac and PVA glue
Medieval distemper
Pigments:
- *Ultramarine*
- *Titanium white*
- *Prussian blue*
- *Light cadmium red*
- *Dark cadmium red*
- *Green chrome oxide*
- *Dark cadmium yellow*
- *Burnt umber*

1 Trace the pattern with a pencil and re-produce it on the parchment, being careful to center it properly: check your margins with a ruler.

2 Apply a fine layer of gum ammoniac (or water mixture) on the areas to be gilded. Place the gold using the loose gold leaf technique (see pages 25–26) or self-adhesive gold leaf (see page 24).

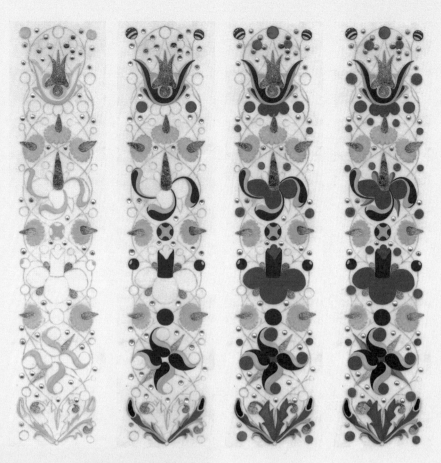

3 Prepare the colors: the dark blue is a mix of ultramarine and Prussian blue, the sky blue is obtained from a mix of the dark blue and white, the red is obtained by mixing light cadmium red with a touch of dark cadmium red. To get the lightest green add white and a small drop of dark cadmium yellow to green chrome oxide, which will give you a slightly olive color. Apply the colors solidly, one after the other: first the sky blue, followed by the dark blue, the red and finally the green. Leave each layer to dry before starting on the next. Wash your brush thoroughly. Be careful to apply the paint uniformly.

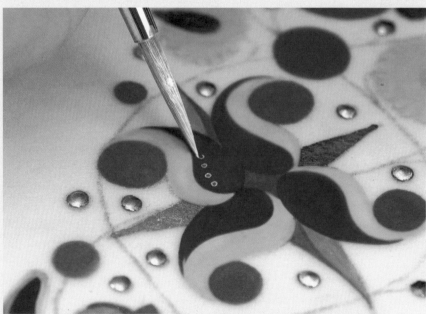

4 Add the white highlights: the circles should be done in two stages, as explained on page 35. The small white lines are very fine and even.

5 Draw the stems with an extra-fine brush loaded with finely ground burnt umber. Remember to work towards you, sliding the brush's hairs in the direction of the pattern.

6 Finish the frieze by tone on tone outlines around the flowers and small circles. The colors are the same (dark cadmium red, Prussian blue and green chrome oxide) only a little darker. Outline the gold patterns in burnt umber.

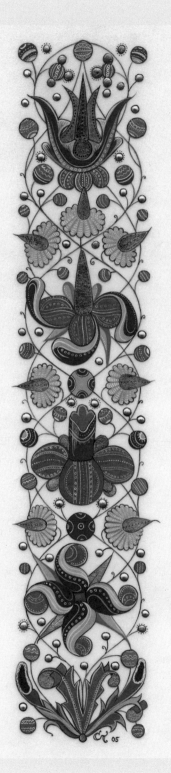

7 Add the last details: highlights in burnt umber on the small gilded parts and a few flourishes in white.

MOROCCAN SHAMSA (ROSETTE)

This shamsa is taken from the *Royal Illuminated Manuscripts of Morocco*, a calligraphy work by Abd al-Nabi al-Fassi in the nineteenth century (a copy of "Sahih Al-Bukhari" ms. 1441). The pattern might appear complicated, but it isn't unattainable if you work methodically. You will be able to concentrate on the fineness of the lines, practice in tracing interlacing with precision (which always passes alternately over and then under) and in posing gold leaf in small spaces.

You will see that using several gilding techniques in the same pattern gives beautiful results. As for the painting, it isn't difficult: you fill in the spaces around the flowers and calligraphy with solid colors.

Materials

Parchment (goatskin)
Pasted to cardboard
Dimension of the work: 5⁵/₁₆ × 5⁵/₁₆ inches
Three gilding techniques are used:
- *The gold on the interlacing was applied on gilding paste (but you can use a gum ammoniac mordant).*
- *The calligraphy is gilded in leaf on PVA glue (but you can use medieval gesso. In this case, do this step before the interlacing because of sanding).*
- *The flowers are done in mineral gold powder applied directly onto the parchment (but you can use shell gold on a fine gesso, done before the interlacing).*
Medieval distemper.

Pigments:
- *Titanium white*
- *Ultramarine*
- *Dark cadmium yellow*
- *Lamp black*
- *Red ochre*
- *Light cadmium red*
- *Green chrome oxide*

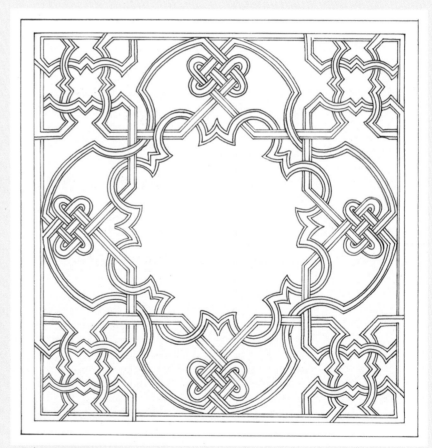

Enlarge to 140%

1 To trace the pattern, proceed in two stages: this will help you not to lose yourself in the pattern's meanders. Trace the interlacing and the frame first, using a ruler. Be precise in your lines. Reproduce the design onto your parchment with a pencil, being careful to center it, checking your margins with a ruler.

3 Apply the gold leaf according to the instructions on pages 24 to 26, whether you are using loose gold leaf or self-adhesive leaf.

2 Apply the mordant: either gum ammoniac or gilding paste. For this design, using gilding paste is easier, because it holds better than the gum (see page 23).

4 Re-trace the outline using a ruler and a technical pen with India ink.

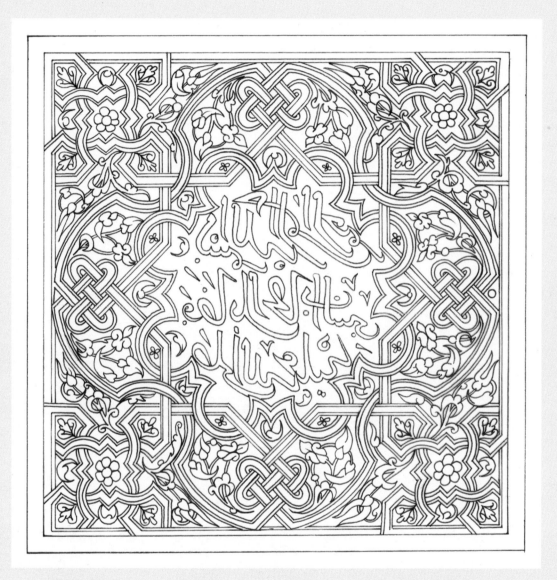

5 Trace the calligraphy and the flowers in the blue areas. Reproduce them on the parchment, superposing the copy properly. You can also draw a small cross on the tracing paper to show where the top of the pattern is; do the same on the parchment so that you know which end is up.

6 Apply the PVA glue to the calligraphy. Leave it to dry and then apply the gold leaf (either loose or self-adhesive). Draw their outlines in ink. Work on the small flowers with the gold mineral powder. Leave it to dry. Prepare the blue paint by mixing ultramarine with a touch of titanium white. Apply it solidly in two or three layers. Do the flowers' outlines in black ink. Add a touch of red (light cadmium red with a drop of red ochre) in the loops of certain letters.

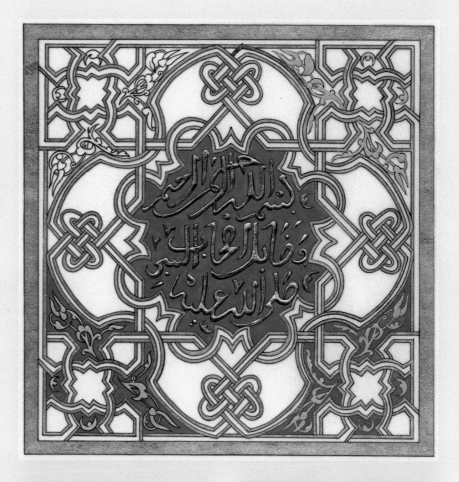

7 Trace the flowers in the red areas. Apply the red and then do the outlines. Leave the parchment to dry between each layer.

8 Do the same with the black: trace the flowers in these spaces, apply the gold mineral and then the paint (lamp black). Add the black outline.

9 Do the same with the green, a mix of green chrome oxide with a touch of dark cadmium yellow and titanium white.

10 Add small white points and redo the black outline if the paint covers it.

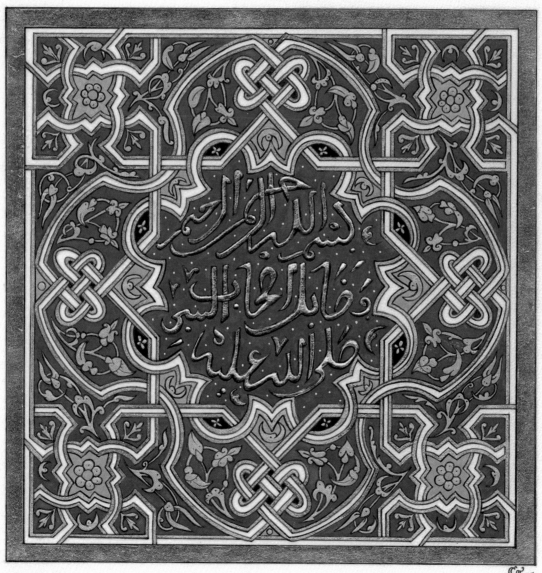

THE DRAGON AND THE ELEPHANT

This composition is taken from the Aberdeen Bestiary, a thirteenth-century English manuscript (page 65v). This illumination serves to illustrate a commentary concerning snakes. The dragon is the biggest snake, to the point of being able to strangle an elephant. The text recounts that the dragon has a small mouth; it doesn't kill with its teeth, but with its tail. The limner added the numerous fangs, without a doubt to make the animal look more aggressive, as well as the wings, which aren't described in the text. The description refers to an African python that can kill deer but not elephants... another freedom of interpretation taken by the limner!

This design will allow you to practice opaque painting and will give you a first try at gradations. The gold is set on medieval gesso, using a leaf of pink gold.

Materials

Parchment (goatskin) pasted onto cardboard
Dimensions of the work: 4¹⁄₁₆ × 3⅜ inches
Gilding gesso
Pink gold leaf
Medieval distemper

Pigments:
- *Titanium white*
- *Prussian blue*
- *Ultramarine*
- *Dark cadmium yellow*
- *Red ochre*
- *Light cadmium red*
- *Dark cadmium red*
- *Ercolano red or cinnabar*
- *Burnt umber*

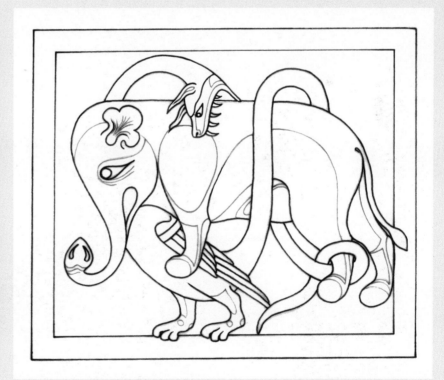

1 Trace the pattern with a crayon and reproduce it on the parchment, being careful to center it: check your margins with a ruler.

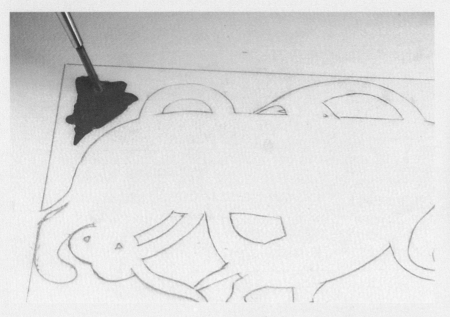

2 Before placing the gold, use the medieval gilding gesso technique. Apply the gesso, which you will have prepared according to the instructions given on pages 21 and 22.

4 Cut out a piece of leaf a little larger than the surface to be covered. Make a small paper tube of about 5mm in diameter and use it to blow warm air to moisten the gesso. Apply the gold. Do the same for the entire surface to be covered.

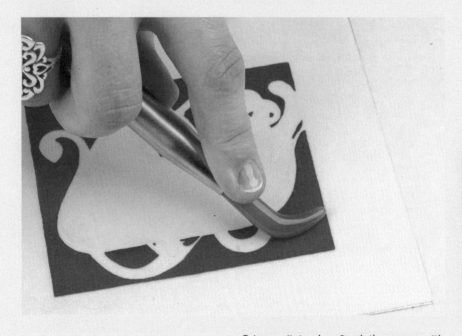

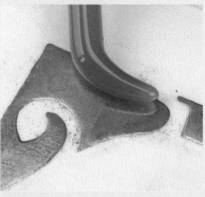

3 Leave it to dry. Sand the gesso with sandpaper with a grit of between 21.8 and 18.3 microns (500-grit, for example) to make the surface perfectly even. Then polish the gesso with an agate burnisher, which you will have heated according to the instructions on page 26.

5 Dust off the surplus. You can burnish the gold once the gesso is rehardened after having been softened by your warm breath. Begin by testing a corner of the gilding, gently at first, to check that the stone doesn't "catch" on the leaf. If the gold scratches or becomes dull, wait longer. Usually burnishing is done within an hour from the time the gold is applied, but sometimes a bit more time is needed, depending on the ambient humidity. No matter what, though, burnish on the same day.

6 Now apply the colors. Start with a layer of light blue on the dragon and the frame, and then outline it in dark blue. To prepare the different blues, use ultramarine pigment with a touch of Prussian blue to make it darker. Progressively add white to obtain lighter blue.

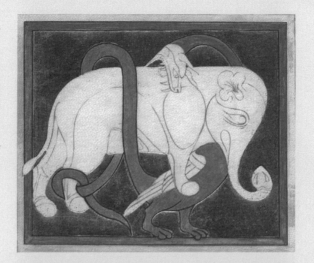

7 Add blue shadows that are darker than the background but lighter than the outline. The separation between the shades of blue should be clean, perfectly following the curves of the dragon's body.

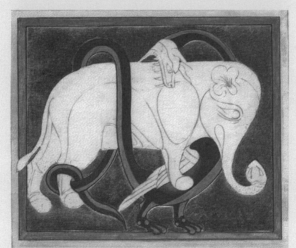

8 Between the light blue and the darker blue, apply a "band" of intermediary blue so that the difference is less radical.

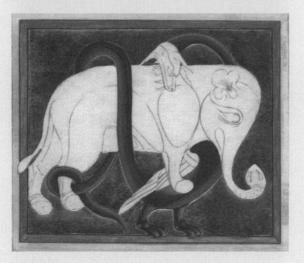

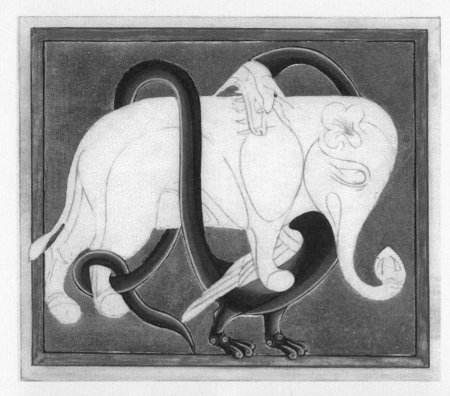

9 Add white highlights next to the sky blue (the background color), using titanium white.

10 Apply a very pale, very watery pink layer all over the elephant with Ercolano red or cinnabar. Then do a layer of watery red ochre on the shadow areas. The pencil lines should be barely visible.

11 Do three or four layers of red, leaving a lighter intermediary "band" to the background color. Add brown outlines by mixing burnt umber with Prussian blue, and then draw in the shape of the eye.

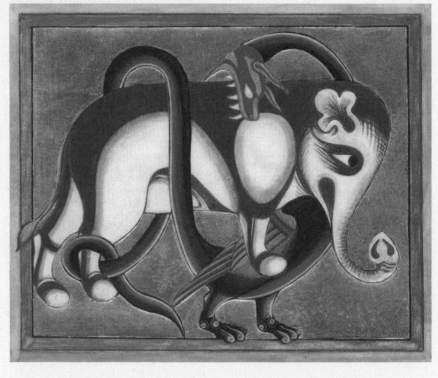

12 The dragon's wing is orangey and red and its head is wine color. The orangey color is obtained with dark cadmium yellow with a touch of light cadmium red; the red by adding a touch of dark cadmium yellow to light cadmium red; the wine color is obtained with dark cadmium red with a touch of light cadmium red and white. Do the light and shadow areas.

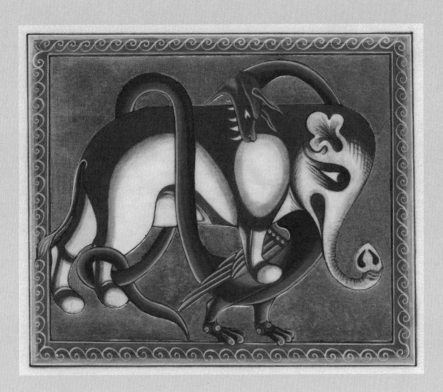

13 Finish by blending the colors on the dragon's head. With a damp brush, gently go over the transition areas. Add highlights with a pen, according to the instructions on page 35.

THE MARRIAGE

This composition is a liberal interpretation of an illumination taken from a thirteenth-century Parisian manuscript: Apparat sur le Décrétales de Grégoire IX (page 216, ms. 89). The priest, in the center of the drawing, receives the couples' consent by joining their hands. The wife makes an approving gesture with her left hand. The interest in this creation lies in the garments. In the Roman epoch and at the beginning of the Gothic era, garments were rather stylized: the background was solid, and the folds simply outlined in black. It was the same for the faces, very white without relief, with fine lines in lamp black. The gold was applied on gum ammoniac mordant and the colors applied with medieval distemper.

Materials

Parchment (white kidskin)
pasted onto cardboard
Dimensions of the work: 4¹⁵⁄₁₆ ×
3¹⁵⁄₁₆ inches
Gum ammoniac mordant
Self-adhesive gold leaf
Medieval distemper

Pigments:
- *Titanium white*
- *Indigo blue*
- *Ultramarine*
- *Minium*
- *Lamp black*
- *Red ochre*
- *Light cadmium red*

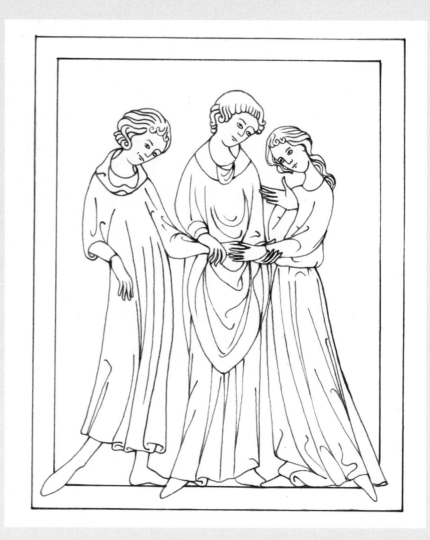

1 Trace the pattern with a pencil and reproduce it on the parchment, being careful to center it, verifying your margins with a ruler.

2 Apply the gum ammoniac mordant. Using scissors cut out bands of self-adhesive gold leaf, slightly larger than the surface to be covered. Moisten the mordant by blowing warm air through a paper tube and then place a band and press down to make sure it sticks properly. Remove the tissue paper.

3 Do the same for the entire edges of the frame. Dust off the surplus gold with a gilder's mop. Don't hesitate to refer to the instructions on page 24.

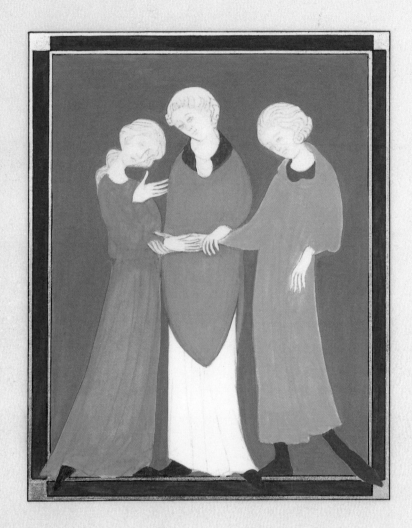

4 Now prepare the solid colors. For the frame, mix ultramarine and indigo and, for the background color, add a little titanium white. Use minium with a touch of ochre red, a touch of light cadmium red and titanium white for the pink garment on the right, minium for the garment on the left, and lamp black, titanium white and a touch of ultramarine for the garment in the middle. Apply the solid colors first, starting with the lightest. The paint should cover properly, but leaving all the pencil lines transparently visible.

5 Leave the paint to dry and then draw in the folds in lamp black with an extra-fine brush. The tips of the folds should be as fine as a strand of hair. At the end of each line, delicately lift the brush off the parchment.

6 In the original illumination there wasn't any relief. However if you want to add some to your characters, add light shadows in the hollows of the garments' folds. For this, the tone should be darker than the solid colors and somewhat fluid. Work in small touches, lightly brushing the surface of the parchment.

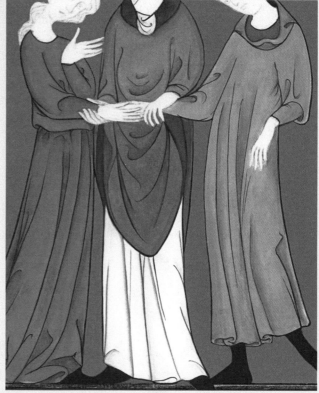

7 Spread the shadow in the base color with a clean, slightly damp brush so that there isn't an abrupt rupture, but rather a light gradation. These shadows should be done before the black outlines, which shouldn't be drawn in the color to avoid dirtying it.

8 For the background grid, draw in fine lines 3 mm apart with a pencil and then with a fine brush loaded with dark blue paint, go over each line all in one piece.

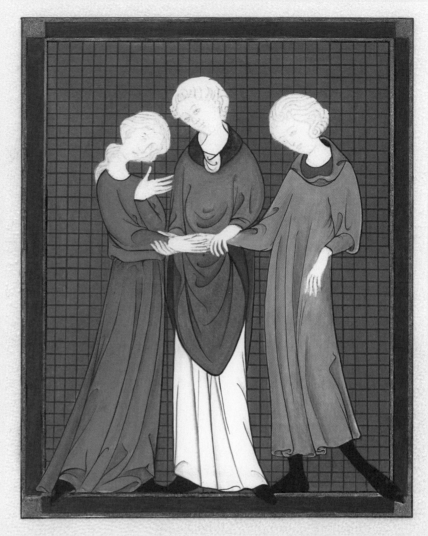

9 If you have to restart the line, go back a few millimeters from where you left off. If you don't feel confident enough you can draw the lines with a pen and using a ruler (as for the scribe's frame on page 63).

10 Erase the pencil lines with a kneaded eraser by tapping it lightly on the surface. Add white points in the center of each square. Encircle a point in every other square on alternate rows. The other point is encircled in red.

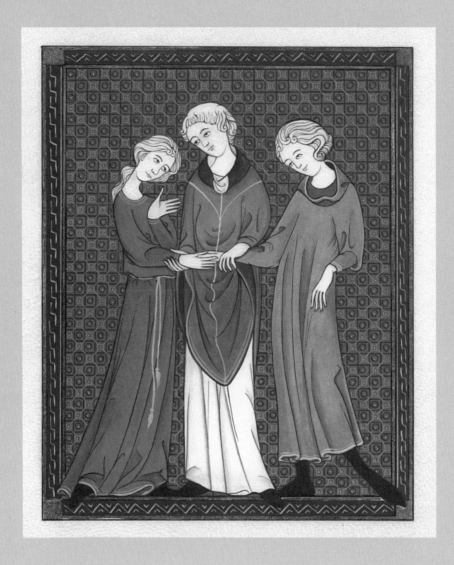

11 The faces are very stylized: there isn't any relief, not even flesh-color. Simply draw the outlines in black, preferably with a fine brush, or with an extra-fine point pen using indelible ink if you feel more at ease with this method. Finally, add a few high-lights in the blue frame, in the belts and edges of the garments.

THE FACE

This face was done on goatskin stretched on wood, following the simplified method described by Theophilus, a twelfth-century craftsman monk, in book 1 of his *De Diversis Artibus* (The Various Arts). You can follow the stages to create all relief faces, because this method offers very different results to that presented in the wedding scene on page 54.

1 Reproduce the drawing with a pencil (don't do the outlines in ink). Blur it with a kneaded eraser so that the carbon in the pencil doesn't dirty the color.

Materials

Parchment (goatskin)
stretched on a wooden board
Dimensions of the work: 2⁹⁄₁₆ × 1¾
inches
Medieval distemper

Pigments:
- *White lead (or failing that, tita-nium white)*
- *Ultramarine*
- *Exedra (red ochre mixed with black)*
- *Lamp black*
- *Havana ochre*
- *Yellow ochre*
- *Red ochre (or cinnabar)*
- *Vermillion*
- *Burnt umber*
- *Green earth*

2 Apply an undercoat of highly diluted white all over the face, including the eyes, without worrying that the pencil lines appear transparently. If the face is pale—Theophilus talked about "decrepit men"—add highly diluted green earth in the shadow areas. Do a highly diluted blue undercoat on the clothes and Havana ochre for the hair.

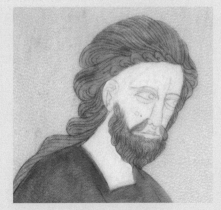

59

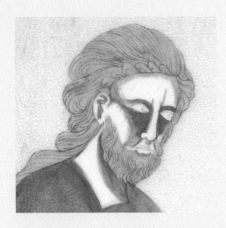

3 Mix equal portions of red ochre and yellow ochre. If the tint is tanned, use the color as it is. If the skin is pale, add white to this mix, called posch. Apply the posch under the eyes, starting from the temples, then the inner corner of the eye following the edge of the nose, going round the nostril. Apply it under the eyebrows, under the lips, along the hairline and auricle. For the neck—do a triangle to make the chin stand out. If necessary mark the wrinkles on the forehead and neck.

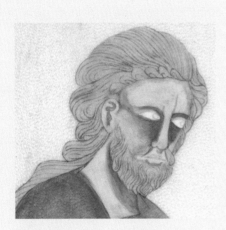

4 Add white to the color used for the posch and paint the rest of the face with the pink tint. The contrast should be well marked.

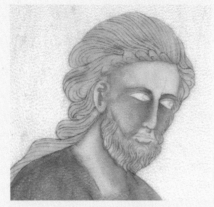

5 Pass a clean, slightly damp brush between the posch and the pink to blend the two colors. Be careful not to spread the posch into the pink, which would ruin the volume effect: better to proceed in the opposite way, by spreading the pink into the shadows (which can always be accentuated afterwards, while it is harder to lighten a darker color).

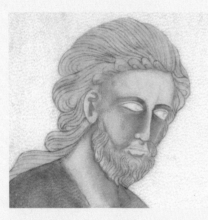

6 Add white to the pink to highlight the nose by painting a small ball on the nostril, on the tip and along the nose. Go back up along the ridge (inside the outline) to the eyebrow. If your character has a slightly rounded face (like the scribe on page 62), paint two small triangles of light on the cheeks. If he hasn't got a beard, highlight the chin in the same way as the nose (a ball on the part that has most relief). This first highlight, that is called first stage highlighting, serves to accentuate the volume:

therefore it is painted on the elements that stand out the most on the face. It should be blended with a clean, slightly damp brush, in small touches. Don't even out the different colors: the posch should always be visible.

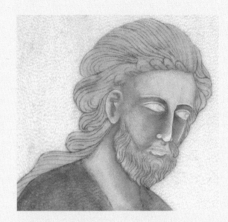

7 Work on the highlights again, this time using pure white: paint a small ball on the nostril, on the tip of the nose, and a fine line along the ridge with a very fine brush. This is called second stage highlighting.

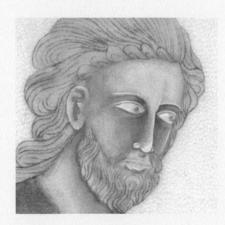

8 Apply veneda (which Theophilus called the mix of black and white) on the eyes' pupils and leave it to dry; add more white to the veneda to obtain off-white and cover the two sides of the pupils and the pupils themselves. Leave it to dry and then apply pure white around the pupils. Add a drop of water and leave it to dry once more. This stage gives relief to the eyes. After-

wards, darken the pupils. If you find this difficult, you can simply fill the pupils with black without adding any gray. In ancient illuminations, there is almost never any iris: only the pupil which is painted intense black. There isn't any reflect to lighten the eyes. The pupil is often "stuck" to the upper lid, which is called "the mystic look."

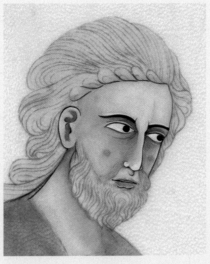

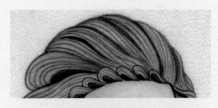

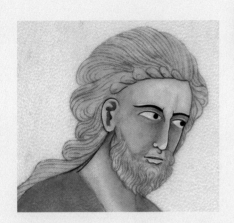

9 Using a mix of red ochre and black, which is called exedra, redo the outline of the face in a fine line, the upper part of the eyes, the pupils and the nose. Underline the inside of the mouth, the opening of the nostrils, around the ears and the line under the lower lip.

10 Work on the inner part of the eye and the folds in the eyelids with the posch. Using perfectly ground, slightly dry vermillion add touches of pink to the lips and cheeks with the tip of the brush.

11 Apply a Havana ochre undercoat to the hair and beard. Go over the outlines of the locks with burnt umber, following the pencil lines. Paint in shadows on the curving parts. Blend the colors with a clean, slightly damp brush between the two colors, along the transition line.

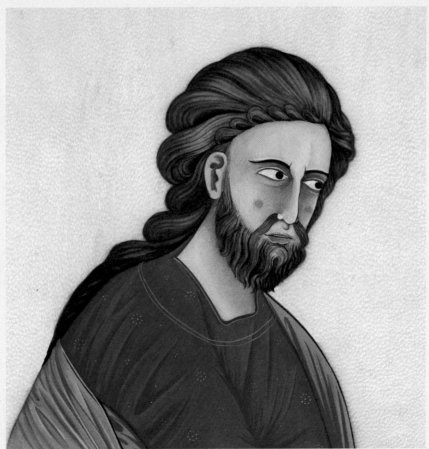

12 Finally, to add highlights to the hair, you can soak the pigment, that is to say moisten the color to remove a little to bring out the undercoat. Don't add white, which would dull the color. Shape the tunic, referring to the garments worn by the wedding couple and the scribe, and do the last details.

THE SCRIBE

This composition is taken from the Aberdeen Bestiary (page 81v). The calligraphy has been voluntarily modified to represent any scribe and not Isadore, described in the text: *De corpora et sanguinis domini* instead of *Ysidorus de natura hominis Isadore*. The work on the relief is more accomplished than in the scene on page 54. The garments and face have been carefully worked on. The gold has been laid on gesso and the colors applied with medieval distemper.

Materials

Parchment (vellum)
stretched on a wooden board
Dimensions of the work: 7¹/₁₆ × 4¾
inches
Bole
Bright half-yellow gold leaf
Medieval distemper

Pigments:
- *Titanium white*
- *Blue (mix of indigo and ultramarine)*
- *Minium*
- *Havana ochre*
- *Yellow ochre*
- *Red ochre*
- *Light cadmium red*
- *Burnt umber*
- *Green chrome oxide*

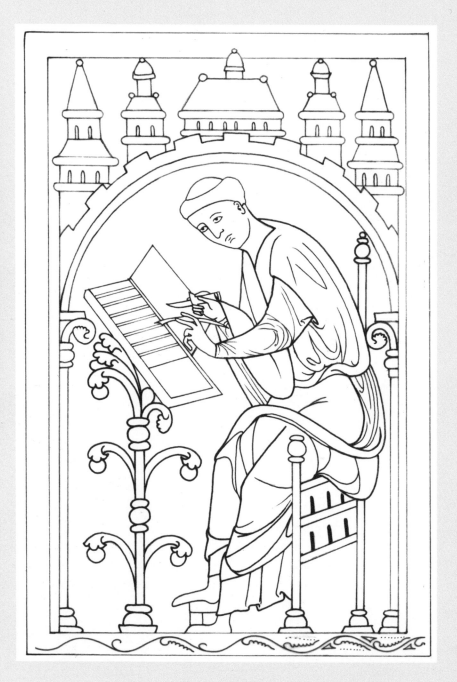

1 Trace the pattern with a pencil and reproduce it on the parchment, using a ruler to make sure it is properly centered. Warning: the frieze shouldn't be reproduced until the gradation of the frame is finished. Be careful not to break the curve and to keep the suppleness of the flourishes.

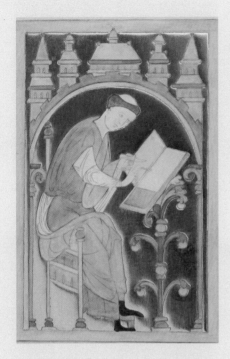

2 Apply the gesso to the parchment and lay the gold according to the method you find comfortable (see pages 24 to 26). Leave it to dry and then do a well-watered-down undercoat, being careful not to leave brush marks.

3 Work on the frame doing successive bands bound by a line drawn with a dip pen. Load the point of the pen with paint. Attention: the paint should be rather liquid.

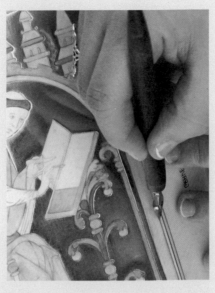

4 Using a square or a ruler, draw the outside outline in dark green (pure green chrome oxide), then a line inside the frame, 2 mm from the first. Don't squash the pen onto the paper to avoid blotting. All you have to do is let the pen rest lightly on the

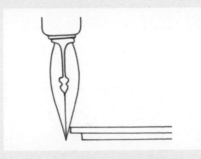

paper and draw the line, a little like using a ball-point pen. If it doesn't work, dip the paint-loaded tip in water (do some tests on scrap paper first). Place the ruler slightly under the exact line to take into account the thickness of the pen.

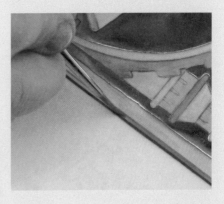

5 Apply the color to the inside of the band with a fine brush. At each line add a little white to gradate the color.

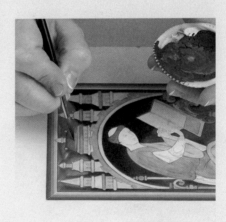

6 Next, work on the architecture: for the gradation of the roofs, juxtapose lighter and lighter bands of color, by adding white to the blue or by diluting the blue with water each time.

7 Contrary to the bands in the frame, the colors on the roofs are blended. Pass a slightly damp brush between the bands to soften the transition. If you can't manage this, you can give an illusion of gradation by doing thinner bands, each slightly lighter than the last.

8 Proceed in the same way for the other colors (minium and light cadmium red), trying to dilute the colors to lighten them. In this way it won't go from pink to salmon. For the green chrome oxide you can add titanium white to it.

9 Apply the colors to the feet of the writing desk and the chair. As in the initial on page 38, the concave parts of the stems and the topside of the flowers are darker; the rounded part of the stems and the tips of the flowers are lighter.

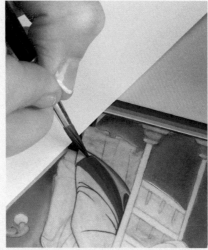

10 Now start on the garments (see page 35). As in the preceding pattern, do the main folds with a brush. Warning: you should be able to transparently see the pencil lines. You can already start to play with thicknesses by pressing the brush more or less to the parchment to give natural movement to the garment.

11 Start with the three blue colors: light, medium, dark.

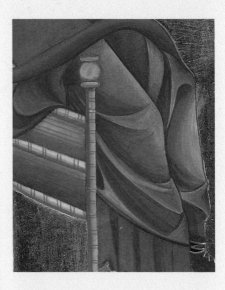

12 Then blend these areas by working in the same way as for the roofs. Do the same for the red garment, trying to avoid adding white to lighten the tint. Try to work by diluting the color or by adding yellow to the areas of light to get an orangey effect rather than pink.

13 For the face, refer to the instructions on page 59. Do an undercoat in white lead and posch, then pink that you have blended with the posch. Apply the veneda and the exedra, as well as the first and second stage highlights.

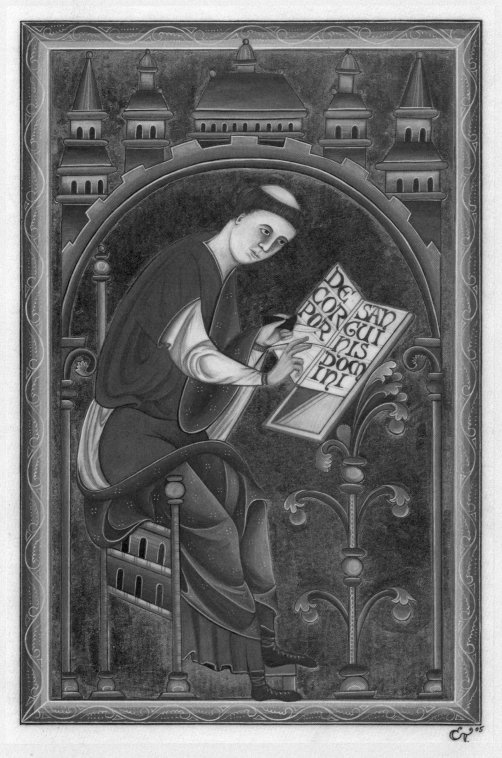

14 Add the final small touches. Add small white points and twirls on the garments, the calligraphy and all the white highlights. For the frieze, start with an even sinusoidal line. Add small loops, followed by the petals and finally the small points and triangles (see pages 68 and 39). Warning: the loops should grow out of the main "stem." Avoid breaks.

Finishing Touches

Friezes, grids and flourishes are the small details that emphasize your work and add delicacy and refinement. Very discreet, they need proper attention to master the finesse and regularity of the lines. All these patterns will help you to add the last small touches to your compositions. Don't hesitate to use your own inspirations and create your own personal patterns.

Friezes

Here are a few examples of friezes, some of them very easy, others a little more complex. According to the ornament you want to add to your illumination, the procedure is the same as for white highlights (see page 35). First of all, paint the background of the frame in the appropriate solid color. If you feel comfortable with a brush, paint the highlights with titanium white; the paint should be very fluid. You can also reproduce the pattern with a pencil on the solid color. Blur the pencil lines with a kneaded eraser so that the line is light and doesn't dirty the white paint.

▶ Simple
pattern friezes

66

Example 1, Complex Patterns

1 Paint the background in middle green. Draw the pattern with a pencil. With darker green underline the topside and underside of the flowers.

2 Blend the shadow underneath with the green background and then add fine lines.

3 Add white highlights to the tips of the flowers and triangular groups of three white dots.

Example 2, Complex Patterns

1 Prepare the base color by mixing Ercolano red and dark cadmium yellow. Prepare a gradation by adding a little white each time. Do a light solid background color (by adding a lot of titanium white to your base color). Leave it to dry. Reproduce the pattern and blur the pencil lines with a kneaded eraser. With the orange, outline the pattern and fill in the background.

2 With the red, fill in the background areas of the leaves' shadows and blend them with the orange.

3 To add relief, shadow the concave parts of the leaves with light orange and blend it with the lightest base color.

4 Finally add pure white highlights on the flowers' "lace" and add small white dots.

Grids

Squares can be useful for embellishing backgrounds. They allow you to decorate your compositions, leaving your imagination a free rein. To obtain lovely grids, make sure that they always measure between 3 and 5 mm each side and that they are as even as possible.

Classic Grids

1 Apply a dark blue solid background. Here the color is a mix of indigo, Prussian blue and ultramarine.

2 With a dip pen and a square (as explained on page 62) draw in the grid in lamp black, spacing the lines at 5 mm intervals.

3 Draw small squares in sky blue where each line crosses.

4 Do small red squares in the center of each square.

5 Join the corners of each small square with sky blue paint.

▲ *Enlarged to show detail*

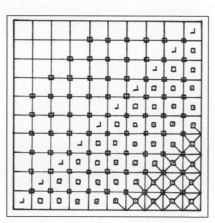

▲ *Pattern*

▲ *End result*

67

Gothic Grids

Typical Gothic grids alternate red, gold and blue squares in a varied way. A white highlight is added to each square. You can alternate the squares however you like, but remember to stick to a certain logic. To make this type of grid, you will find examples in the *Livre de chasse* (Book of the Hunt) by Gaston Phébus.

▲ *Example*

▲ *Example*

"Four-leaf Clover"

1 Apply a solid background color in reddish orange.

2 Do a simple grid in dark red ochre spacing the lines at 4 or 5 mm.

3 With an extra fine dip pen, draw small circles in the center of each square.

4 Using the enlargement opposite as a guide draw a small triangle in the center of each side of the squares: this will give you four-leaf clovers.

5 To finish, add a white dot at the base of the triangles.

▲ *End result*

▲ *Enlarged to show detail*

"Double" or "Triple" Grid

1 Apply a solid background color. Draw a classic grid spacing the lines at 5 or 7 mm.

2 Double each line on the left and triple each line on the right.

▲ *Pattern*

▲ *Enlarged to show detail*

Freehand Patterns

Using the base principle of a double or triple grid, you can create all types of highlights, lighter or darker than the background. For the following grid, do small circles outlined with lines and dots.

▲ *Pattern*

▲ *Enlarged to show detail*

Trompe-l'oeil

1 Apply a solid sky blue background. Draw a triple grid. Here, it was made with an acrylic mixture as a way to highlight the gold leaf.

2 With a mechanical pencil (0.5 mm point), draw in light diagonals in the squares.

3 Paint the bottom triangle in each square dark blue; paint the left and right triangles in mid-blue and the top triangles in bluish white.

▲ *Pattern*

▲ *Enlarged to show detail*

Flourishes

It is also possible to add flowery ornaments. Create twirling stems and then add small petals and white dots in triangular groups of three. You can do white or gold twirls and leaves. For the gold flourishes, draw the patterns with a dip pen with the acrylic mixture and add pure gold powder (980) with a dry brush. Finally, dust off the surplus powder.

▲ *Gilded*
twirls and leaves

▲ *White*
twirls and leaves

GALLERY

This gallery offers a selection of works inspired by different epochs and different styles. Some are reproductions of medieval illuminated manuscripts, and others are more recent creations. They have all been made according to the application of gold leaf and the use of colors explained in this book.

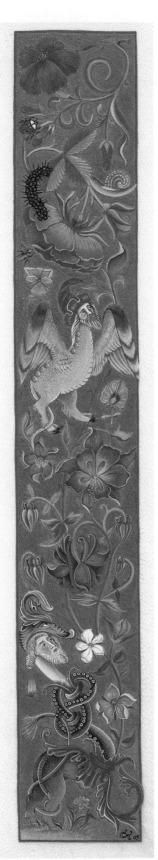

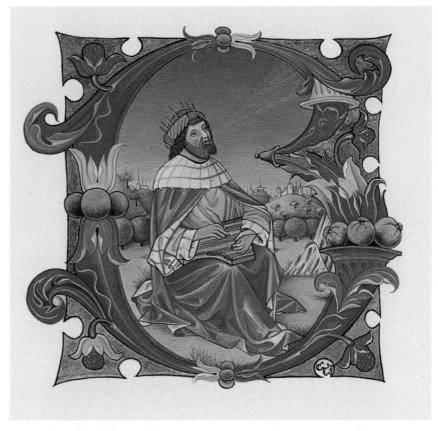

▲ Initial "B" (around 1500)
Initial representing David playing a psaltery. Taken from an antiphonary; the original measured about 22 x 21 cm and introduced the first of the 150 psalms in the Bible.

Calfskin (11 x 10 cm), 22 karat gold applied on gum ammoniac; mineral gold powder, shadowed with burnt umber distemper or for ornaments; medieval distemper.

◀ Grotesque frieze
(first half of the sixteenth century)
From the Cisneros Missal (Archbishop Rico de Cisneros).

White kidskin (28 x 4.5 cm), 23 karat gold powder 3/4, egg-yolk medium.

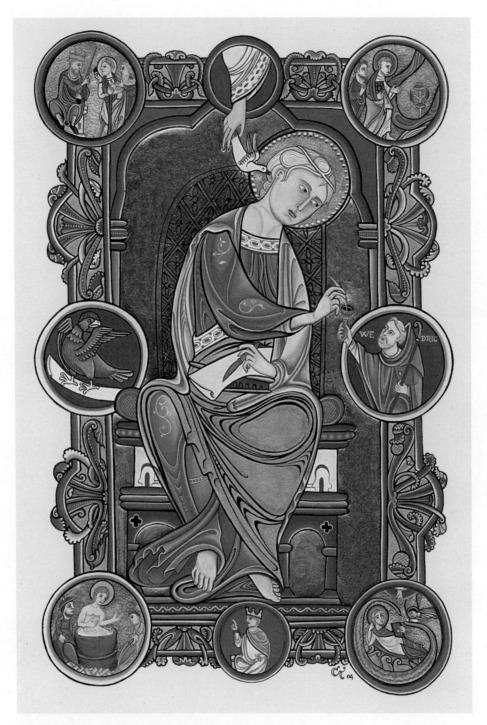

▲ St. John the Evangelist (twelfth century)

*Portrait of St. John the Evangelist, taken from a Gospel book in the Liessies
Abbey, France (detachable leaf, 1146). St. John the Evangelist receives the
Holy Spirit from God, which gives him inspiration, while on the left Wedricus,
Abbot of Liessies, hands him an inkpot. The other medallions represent Bible
scenes, including the baptism of Christ.*

*Goatskin (21.5 × 14 cm), 22 karat gold laid on medieval gesso for the
background and on gum ammoniac for the halo, mineral gold powder for the
garment and the frieze, medieval distemper.*

◀ **The Magi** (eleventh century)

Reproduction of folio 17v of the Lectionary of the Gospels (Munich, Clm. 4 452).

White goatskin (16 x 12 cm), 22 karat pink gold laid on medieval gesso, medieval distemper.

▶ **Tamed baboon** (about 1430)

Reproduction of a folio from the Breviary of Marie de Savoy (Milan, Chambery, BM, ms. 4, f. 319). The red belt with its ring shows that the baboon is tame and he is part of the princely menagerie. Apes were frequent subjects in the margins of manuscript texts.

Beige kidskin, 22 karat gold on medieval gesso and PVA glue, egg-yolk medium.

▲ Archangel Michael fighting the dragon over Mont-Saint-Michel (fifteenth century)

Reproduction of folio 195 in manuscript 65 of the Très Rich Heures du Duc de Berry.

Vellum (19 x 24 cm), 22 karat gold applied on gum ammoniac, shell gold for the angels' wings and the garment of the archangel, medieval distemper.

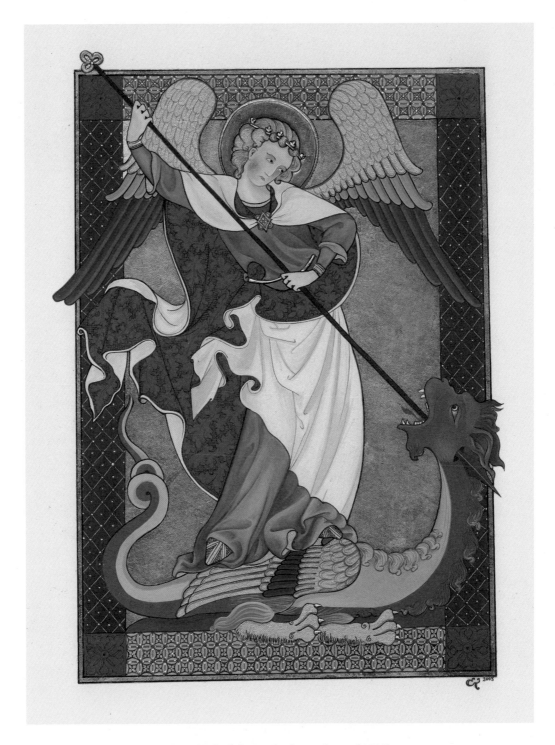

▲ **Saint Michael slaying the dragon (around 1300)**

*Composition inspired by a German Gothic illuminated manuscript
(isolated folio in the Berlin Museum, owner of the Willelham
Codex).*

*Calfskin (12.5 x 17.5 cm), gold applied on gum ammoniac for the
background and on medieval gesso for the halo; pink mineral gold
powder for the archangel's and dragon's wings; medieval distemper.*

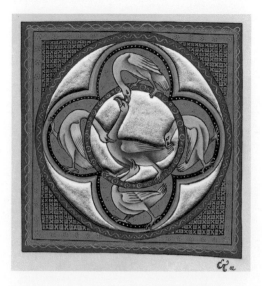

▲ The birds of Aberdeen (end of the twelfth century, beginning of the thirteenth)

Liberal interpretation of folio 36v of the Aberdeen Bestiary.

Beige kidskin (8 x 8 cm), 22 karat gold on PVA glue, egg-yolk medium.

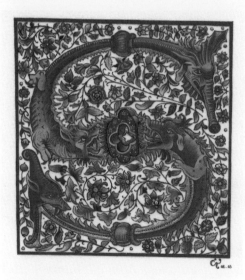

▲ Initial "S"

Pattern inspired by an initial engraved on wood, taken from La Mer des Histoires, *famous incunabulum made in the workshop of Pierre le Rouge (Paris, 1488-1489).*

▲ Dragonfly

Reproduction of folio 115 taken from the Grandes Heures d'Anne de Bretagne. *The colors of the dragonfly's body are different from those in the original illuminated manuscript, and the ladybird was added.*

Calfskin (23 x 7 cm), 23-karat mineral gold powder 3/4, medieval distemper.

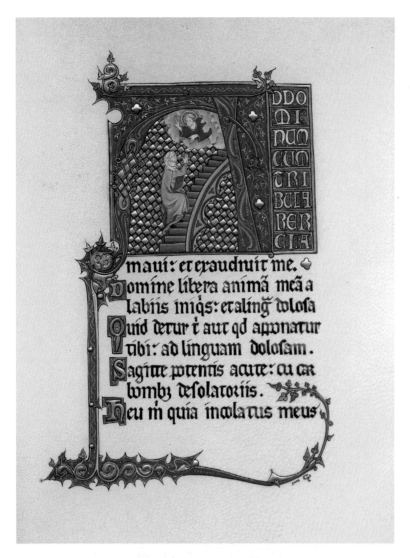

◄ Psalm 1

Reproduction of folio 179v from the Nuremberg Book of Hours. It represents the first psalm and depicts a young woman climbing fifteen steps to heaven.

Kidskin (17 x 22 cm), 22-karat gold on medieval gesso, mordant for the lettering at right, medieval distemper. Gothic Textura calligraphy with my own straight serifs.

▼ Armenian roosters (around 1300)

Personal composition created in the style of the ancient limners of Gladzor.

Goatskin (19.5 x 9 cm), gold on gum ammoniac, mineral gold powder for the frieze, medieval distemper.

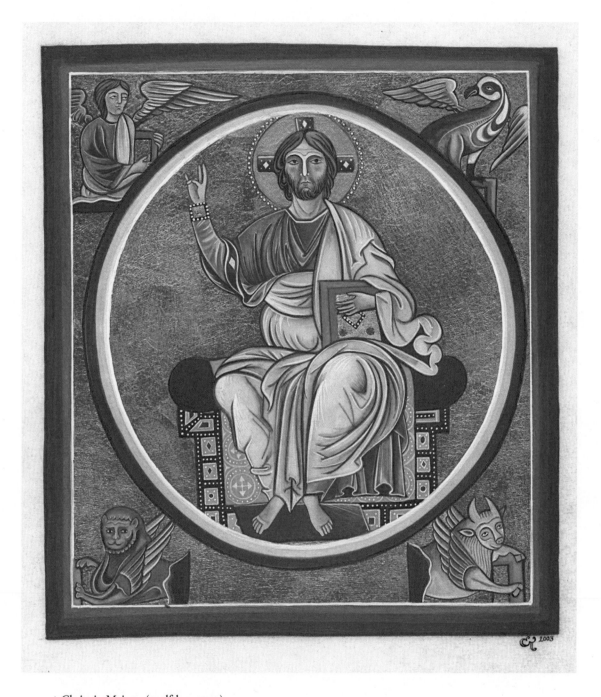

▲ Christ in Majesty (twelfth century)

Reproduction of the miniature of folio 55 of the Sacrementaire de Pons (around 1170–1175, Clermont-Ferrand, France, BM, ms. 63). Christ, sitting on a throne, makes a gesture of benediction with his right hand; the left hand is resting on the Bible. The four evangelists are represented symbolically in the corners: the eagle for John, the lion for Mark, man for Matthew, and the bull for Luke.

Goatskin (13.5 x 15 cm), 22-karat gold on gum ammoniac, medieval distemper.

MANUSCRIPTS

Manuscripts are precious books. Intended for scholars, they were passed from monastery to monastery so that the monks could copy them and own examples of rare, sacred texts. Durand, the Abbot of Moissac, had liturgical books sent from Cluny to give a new breath to the spiritual life in the monastery that had been put in his charge.

The Abbreviations

To understand the references in a manuscript, it is important to know the abbreviations that are generally used.

• Manuscript: ms. Example: "ms. lat. 9474" means "manuscript written in Latin number 9474" (its place in the library where it's kept).
• France: fr. This is one example of an abbreviation used for provenance—where the manuscript was produced.
• Newly acquired manuscript: ms. newly acq.
• Codex: cod.
• Folio: Fol. Example: "Fol. 2v" means "folio 2 verso," indicating the page that's being referred to.

Creating a Manuscript

The stages of creation of a manuscript are numerous. After preparing the parchment (see page 15), the binder folded the skins and cut them to form double pages called bifolios. Each manuscript was composed of several books and each book could comprise 2, 3, or 4 folios (8, 12, or 16 pages). The book usually started with a hair side, and then it was arranged successively flesh against flesh then hair against hair. Antiphonaries were created with parchment folded in two. They usually measured around 17¾ inches (45 cm) high (the size of a sheep), which allowed the entire choir to read them.

Once the pages were in place, lines were drawn for the script. The pages were stamped at the top and at the bottom in regular intervals, first horizontally then vertically. Then the points were connected to the drypoint, in light colored ink or lead pencil. In the twelfth century, text was generally written in two columns with margins large enough for the commentary: the annotations that made reading easier.

The Writing

The now formed books were distributed to different copyists in the scriptorium, a room set apart, usually located close to the warming room so that the scribes could work in good conditions, without cold hands. For the calligraphy, the monks used a goose feather split in two, oak gall ink in different shades of black, and a scraper to correct any mistakes. Historians believe that the monks worked on the manuscripts for about three hours a day, and they spent the rest of their time in religious offices and manual work. Around the beginning of the twelfth century, the changes in the formation of the calligraphy were less frequent, which leads us to believe that the monks had been exempt from certain work and offices. These books were in great demand and work on them needed to advance relatively fast.

Once the writing was finished, the painting work began. The scribes left areas for the pictures in white and, in the margin, indicated the work to be carried out—notes that disappeared with trimming. The